THE
Archive Photographs
SERIES

DEWSBURY

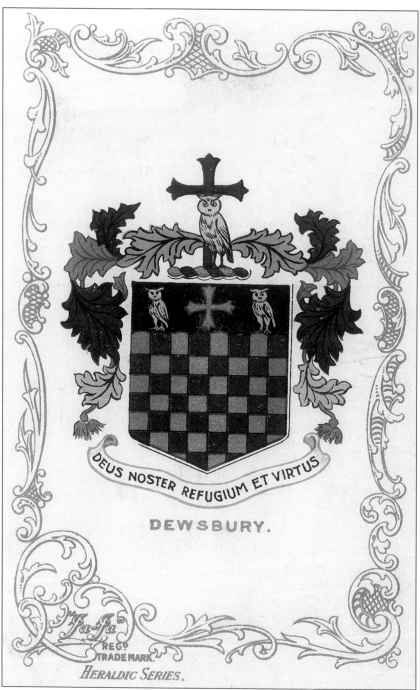

Dewsbury Coat of Arms, on a postcard, c. 1905. The arms were granted in 1893. The chequers (blue and gold) are derived from the arms of William de Warenne, Earl of Surrey, a kinsman of William the Conqueror, from whom he held lands in Surrey, Sussex, Lincolnshire and Yorkshire, including the Manor of Dewsbury. The owls and crosses come from the arms of the Saville and Copley families respectively, who were local landowners. The motto translates to 'God is our refuge and strength.'

THE
Archive Photographs
SERIES

DEWSBURY

Compiled by
Norman Ellis

CHALFORD

First published 1996
Copyright © Norman Ellis, 1996

The Chalford Publishing Company
St Mary's Mill, Chalford,
Stroud, Gloucestershire, GL6 8NX

ISBN 0 7524 0375 3

Typesetting and origination by
The Chalford Publishing Company
Printed in Great Britain by
Redwood Books, Trowbridge

BOWLING GREEN, DEWSBURY PARK.

TO DEWSBURY.

The people here in Dewsbury are
so hospitable, that there is hardly
anything they wont do, to ensure
one having a good time.

Contents

Acknowledgements

The author appreciates the valuable help given by many people
in the preparation of this book.
Thanks go especially to the staff at Huddersfield Local History Library;
also to Ken and Phyllis Lister.
Useful information was gleaned from back issues of the *Dewsbury Reporter*.

Introduction

The rag-and-bone man has virtually disappeared from our streets. His mode of transportation ranged from an old pram to a four-wheeled dray, but was often a two-wheeled cart pulled by a small horse or pony. His approaching cry brought out a few housewives who, in exchange for a bundle of cast-offs, received items of cheap crockery or a few pennies. His payment was meagre because of all the middle men involved in the rag trade who needed their cut.

Some of the more entrepreneurial rag-and-bone men (or 'tatters' as they were known) pitched their vehicles outside schools and proffered a balloon, goldfish or day-old chick in exchange for a bag of rags. Many were the children who ran home in their dinner hour to pester their mums for a carrier bag of discarded clothing.

What happened to the rags which the tatter acquired? A lot of them ended up in Dewsbury where, having passed through the warehouses of a few dealers and undergone various amounts of sorting, they were sent to one of the town's four rag auction houses.

Auctions were arranged so that they did not clash with each other. Up to fifty hard-headed Yorkshiremen arrived at every sale where, catalogue in hand, they examined each bulging bale or sack. The rags showed considerable variation in quality, depending on where they had come from and how they had been treated. Rags from elite residential areas were better than the dirty poor quality ones from mining districts.

Why was there such a demand for rags? Pure wool was and still is an expensive material. The recovery and recycling of wool from cast-off clothing, which could be blended with virgin wool, was a viable alternative.

Many of the rags auctioned in Dewsbury went to the town's numerous textile mills where, through a series of processes which included grinding (teasing out – not violently dragging apart – of the fibres) they were blended with new wool to produce high grade heavy woollen commodities such as blankets, working clothes and military uniforms, at a considerably reduced price.

'Shoddy' and 'mungo' were the respective names for recycled softer, lighter fabrics and harder, thicker ones. Because of adverse connotations, some auction houses preferred to use the term 'soft' and 'mungo' in the descriptions.

Dewsbury did not rely entirely on the tatters' output. Train loads of rags used to arrive in Dewsbury for brief storage in railway warehouses, having been imported from Europe or Asia Minor. These imports included discarded uniforms from the Crimean War and garments which had once clothed inhabitants of devastated areas.

For a century and a half, Dewsbury was the undeniable capital of the West Riding's Heavy Woollen District, which also included Batley, Morley and Ossett. Instrumental in Dewsbury's

rise to prosperity was the invention at Batley in 1813 and 1835 respectively of machines to grind soft and hard rags.

Women were employed in the many rag-sorting warehouses in Dewsbury, which tended to be cold, damp and badly lit. Dexterity, keen eyesight and an alert mind were needed for the menial but skilled task of segregating the hundreds of different kinds of rags. The seams of some of the garments were cut with shears or ripped apart by hand, with noxious dust billowing everywhere.

In the spinning and weaving mills, female labour was also preponderant, girls being taken on in the earlier part of this century as part-timers when they were twelve. They worked mornings at the mill and went to school in the afternoons, until at thirteen years they were recruited full time. Mill work was standing-up work. Against the bang and clatter of the machinery, and to relieve the boredom, millgirls sang as they tended the looms.

Men were employed to maintain the rag grinders, spinning machines, weaving looms, engines, and to keep the entire mill functioning. If a loom or other machine was not functioning properly, a tackler or tuner was called to rectify it. Steam was used to power the machines. The steam engines were kept scrupulously clean because, if the engines stopped, production ceased. Some fine steam engines were discarded when electricity was introduced.

Before alarm clocks were commonplace, some workers relied on the services of a knocker-up to rouse them from slumber. An old or lame man or woman toured around with a pole and knocked on the occupant's window for a few coppers a week. Innumerable mill buzzers, operated by the steam engines, summoned the workers who, if late, were severely reprimanded.

Some of the employees lived in rows of houses built by their employers near the mill. Others travelled in by tram and train or walked a considerable distance. Refreshment breaks were few and canteens virtually non-existent until after the Second World War.

Conditions in the mills reflected the attitude of the owners, some of whom were more enlightened than others. As this century progressed, work practices were steadily improved. But, with the flood of synthetic fibres and cheap imports, the booming days of full employment in Dewsbury's textile mills and rag warehouses were destined to end. No industry of similar magnitude has sprung up in the town.

A legacy of Dewsbury's great days as capital of the Heavy Woollen District is the abundance of Victorian and Edwardian architecture. The buff-coloured sandstone of the buildings was turned almost black with grime from thousands of mill and domestic chimneys. A few well-loved structures have been lost and roads realigned. But, unlike some towns, the heart of Dewsbury has not been ripped out, even though its soul has suffered.

Dewsbury has relatively little stirring history. A monastery probably existed on the site of the present Parish Church. Whether Paulinus preached on the banks of the nearby River Calder in c. 627 is now questioned by some authorities. In the fourteenth century, although Dewsbury was still a relatively unimportant place, many of its families were involved with domestic cloth manufacturing. In the sixteenth and seventeenth centuries, the town was struck by several plagues, when many people died.

In the 1740s, market status was restored to Dewsbury. The terrain around the town was hilly, although the Calder Valley offered scope for new forms of transport to promote trade expansion. The Calder and Hebble Navigation, part river and part canal, was opened from Wakefield to Brighouse in 1764. This included the construction of two cuts (or bypasses) near Dewsbury. A third cut, from Thornhill Lees to Ravensthorpe, was opened in 1798.

From 1840 onwards, several railway companies made incursions into Dewsbury, resulting in the construction of three railway stations in the town, plus extensive sidings and goods warehouses. Road connections were gradually improved although, until 1863 when Savile Bridge was opened, no direct route to the south existed.

The progression from domestic to factory production of cloth in Dewsbury, which increased the need to transport raw materials and finished products, provided the stimulus for many of the transport developments. Most of the local mills were steam-powered, using coal hewn from mines in the Dewsbury area or carried by canal or railway from further afield.

One
The Town

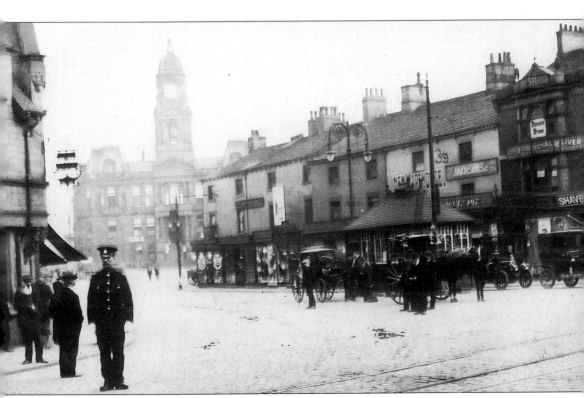

Market Place, *c.* 1908.

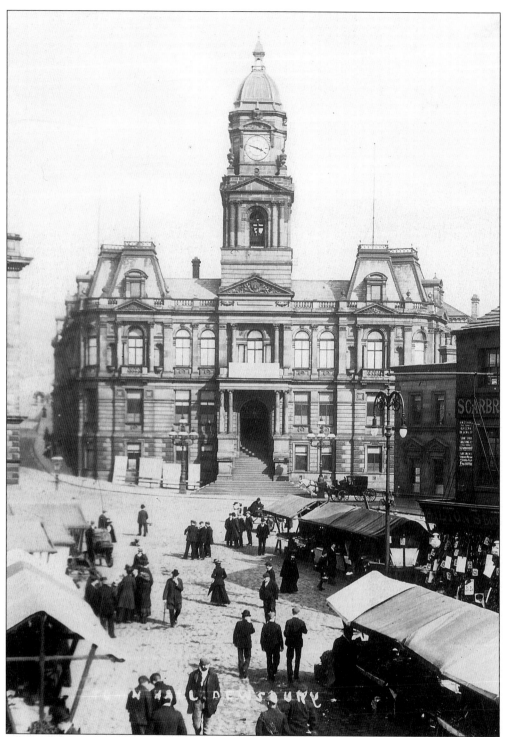

Market Place and Town Hall, c. 1905. An earlier Dewsbury market probably ended after the plague of 1583-5. It was re-established in 1740 and held in the Market Place, from where it spilled into other streets. In 1937, the last stalls in the Market Place were moved to the present site between Foundry Street and Crackenedge Lane, and adjacent to the Covered Market.

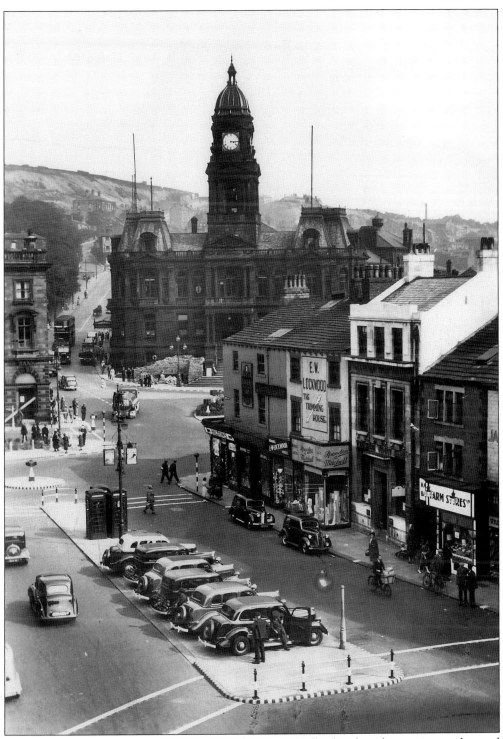

Market Place. The sandbags at the base of the Town Hall, plus the white paint on the road crossings and car bumpers, indicate that this photograph was taken during the Second World War.

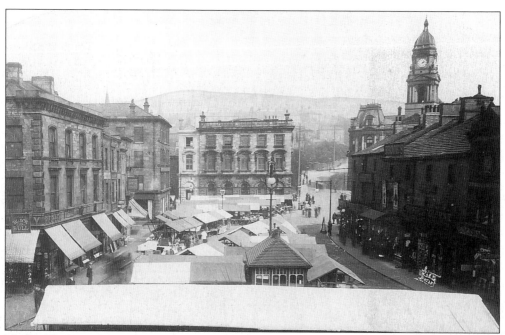

Market Place, *c.* 1904.

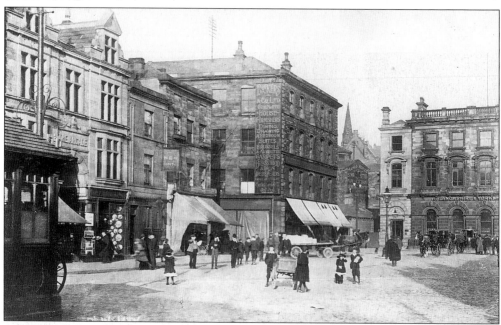

Market Place, *c.* 1906. The large building, centre, is occupied by Bickers & Co. Ltd, who described themselves as 'The Store of Everything for the Home.' Starting in Mirfield in 1859, they occupied several sites in Dewsbury. The Market Place salesroom and warehouse were opened in 1895.

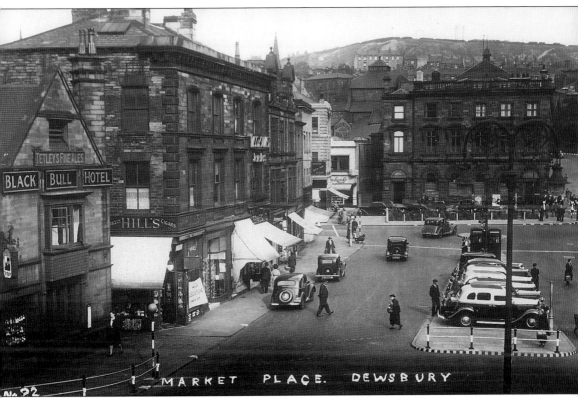

Market Place, *c.* 1940. By then, Bickers had moved to larger premises at the Galleries, Northgate.

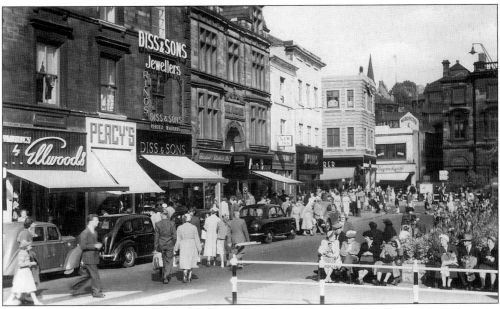

Market Place, 1950s. The Weaver to Wearer shop, right of centre, is on the former Bickers site in a newer building.

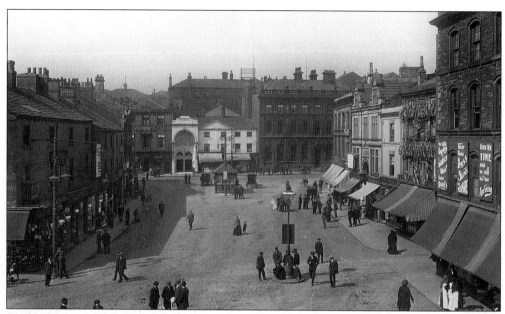

Market Place, *c.* 1908. Bickers' shop is on the extreme right.

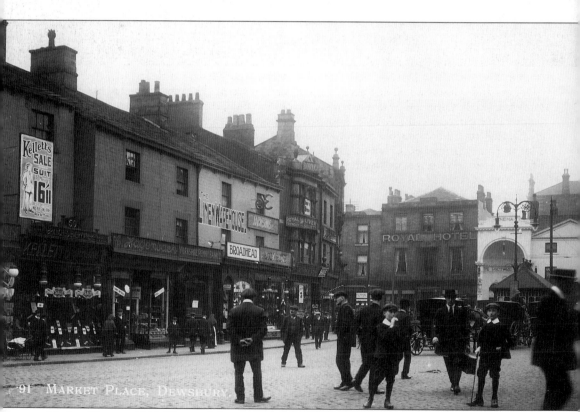

Market Place, *c.* 1910. This and the next photograph were probably taken on the same day.

14

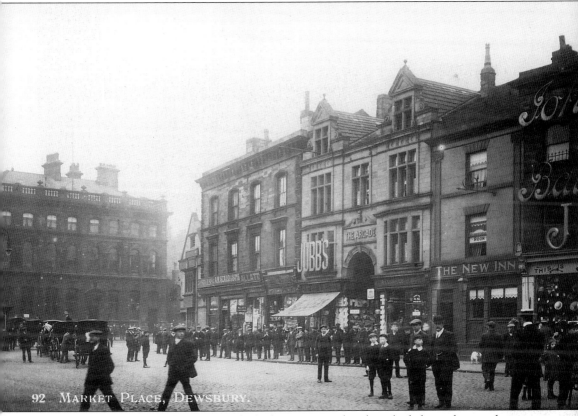

Market Place, c. 1910. Johnson & Balmford, extreme right, described themselves as drapers, milliners and mantle warehousemen. With several stores in the town, they became better known as J & B. Beyond the Arcade is the shop of John Jubb, clothier. He also opened shops in Corporation Street and the Arcade. His Market Place shop became part of J & B in the early 1920s. Kelletts, on the previous picture, are offering made-to-measure suits at 16/11 each, with a 'no fit no pay' guarantee. Other shops encircling the Market Place early this century included confectioners Charles Hagenbach, Broadhead's linen warehouse, Scarr's ironmongery and Allatt's newsagency. Also around the Market Place were three banks and six public houses – the Royal, Man & Saddle, King's Arms, Black Bull, New and Scarborough.

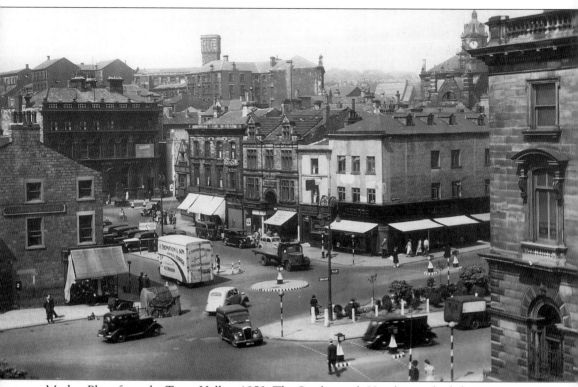

Market Place from the Town Hall, *c.* 1950. The Scarborough Hotel is on the left.

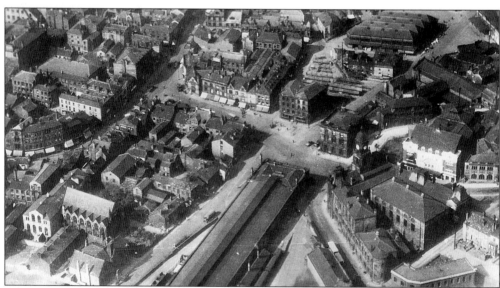

Town centre, early 1930s. The Market Place is in the centre. The Lancashire & Yorkshire Railway's Market Place Station projects along the right-hand side of Long Causeway towards the front of the Town Hall. A long path, which once ran alongside a stream to the Calder, gave Long Causeway its name. Westgate curves away on the extreme left.

16

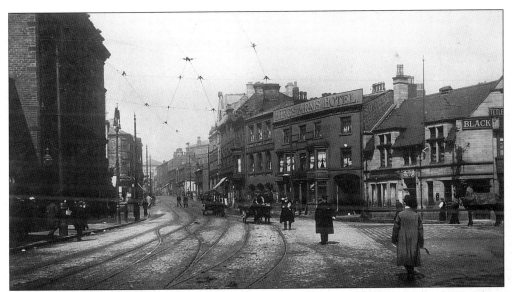

Market Place, right, viewed from Westgate, with Northgate in the distance, *c.* 1907. Three public houses are visible – the Man & Saddle, King's Arms and Black Bull. The latter was built at the turn of the century on the site of an earlier hostelry of the same name and a tobacconist's shop.

Man & Saddle Hotel, Market Place, during conversion to shop premises, *c.* 1930.

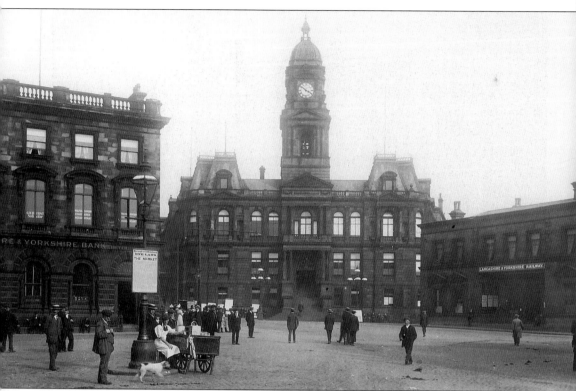

Town Hall, flanked by the Lancashire & Yorkshire Bank and Lancashire & Yorkshire Railway Station, *c.* 1910. The foundation stone for the Town Hall was laid on 12 October 1886 by the Mayor, Alderman T.B. Fox. Since its opening in 1889, it has been the focal point of many celebrations. The magnificent stone edifice, which cost £46,000, reflects the former prosperity of the town. The design was influenced by Italian and French architectural styles. As well as its fine Victoria Hall, the structure included council chambers, the mayor's room, a court room and offices. In the foreground is one of the ice cream carts of John Cadamarteri. 'Caddy's' ices were famous in Dewsbury from 1902 to 1980. Equally well-known was the factory and parlour in Robinson Street, which was opened in 1925 and demolished in 1980 to make way for the Princess of Wales Precinct.

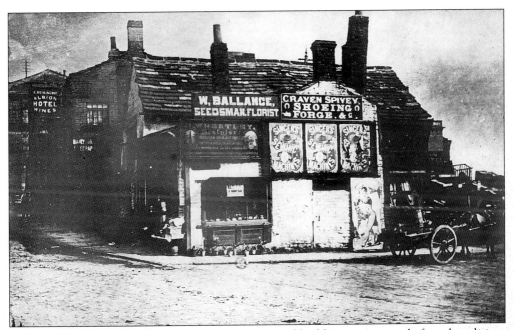

Town Hall site, early 1880s. The conglomeration of buildings, seen just before demolition, includes a hotel, shoeing forge, cottages and shops. W. Ballance moved to a shop in the Market Place proper.

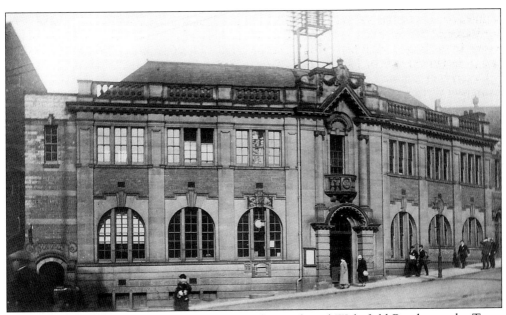

Post office, c. 1925. It was erected in 1908 on the Leeds and Wakefield Road near the Town Hall. In the 1920s, the staff numbered around 200.

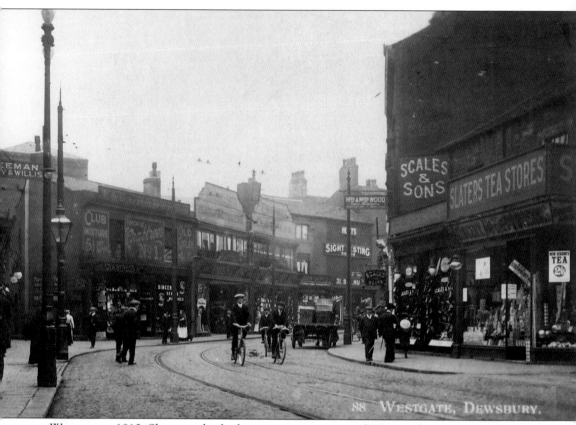

Westgate, *c.* 1910. Slaters, right, had grocery stores in several West Riding towns.

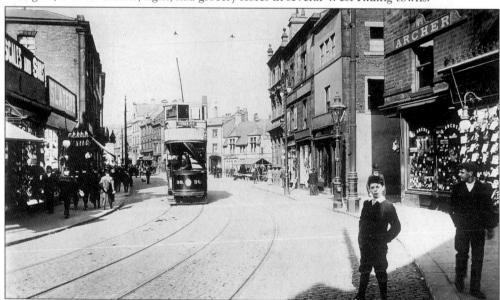

Westgate, looking towards Northgate, *c.* 1907. Slaters is on the left. Opposite, boot and shoe manufacturer Thomas Archer (later T. Archer Ltd) survived at 1 Westgate for over half a century, despite being next to rivals Freeman, Hardy & Willis at No 3.

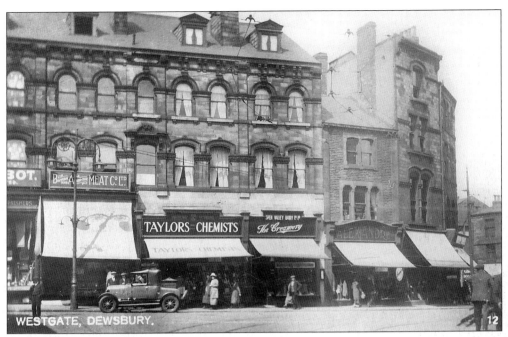

Westgate, *c.* 1925.

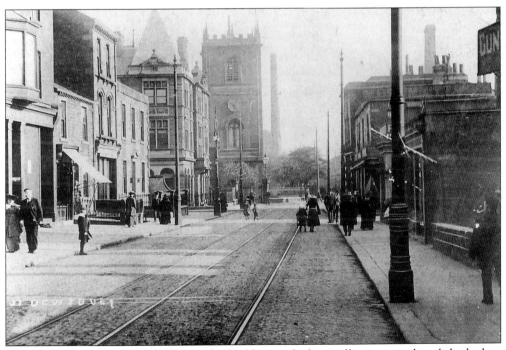

Church Street, 1904. Church House, the building with the small spire, was demolished when Vicarage Road was made into a dual carriageway.

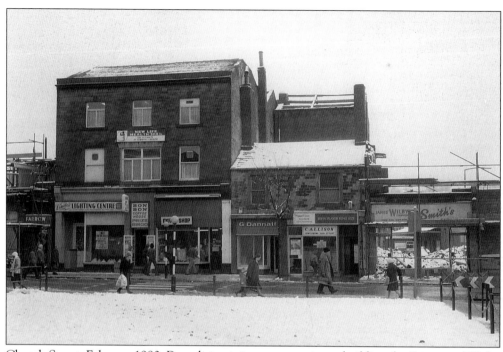

Church Street, February 1980. Demolition is in progress prior to building the Princess of Wales precinct. McDonald's restaurant was later built on the snow covered area in the foreground.

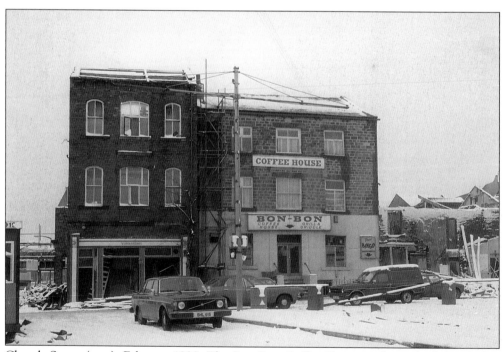

Church Street (rear), February 1980. The Bon-Bon Coffee House at the end of the old bus station is about to disappear. It was much frequented by travellers. In earlier years, the upper floors were used as a billiard hall.

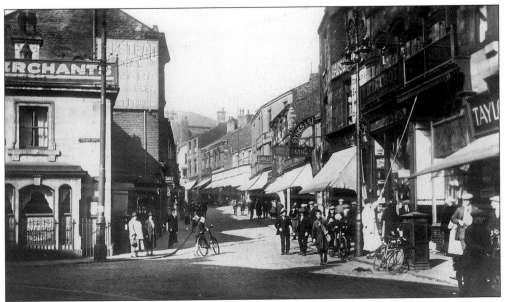

Daisy Hill from Westgate, *c.* 1922. John Edgar Halstead, tobacconist, had several shops in Dewsbury, including one at the bottom of Daisy Hill, left. In 1915, Halstead's Number One Mixture cost 6d per oz or 8/- per lb.

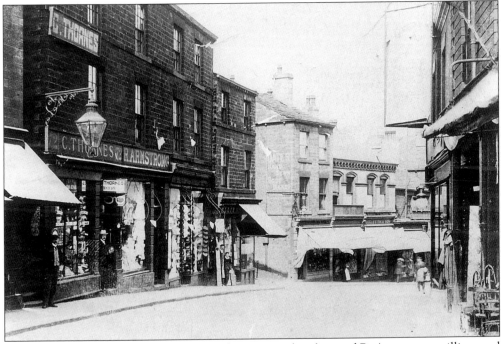

Top of Daisy Hill, 1904. The shops of C. Thomas, watchmaker, and R. Armstrong, milliner and draper, are visible, left. According to some old directories, Daisy Hill was regarded as a continuation of Westgate.

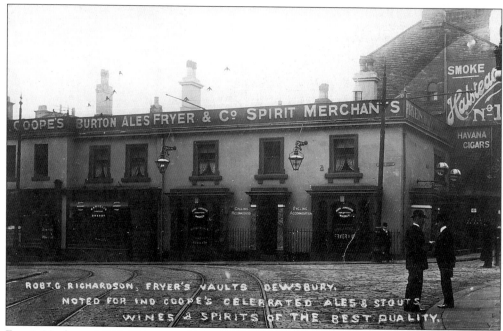

Fryer's Vaults, *c.* 1908. This very old building, which stood in Church Street, was demolished *c.* 1960 to make way for new property. It reputedly had topless waitresses in the 1920s and 30s!

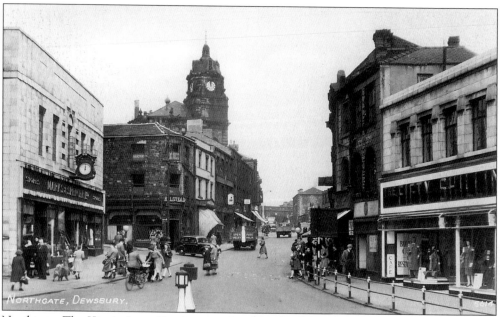

Northgate. The King's Arms Hotel was replaced by the Fifty Shillings Tailors building in the late 1930s. Bailey's Cafe is on the top floor. The clock tower of Dewsbury Co-op is prominent.

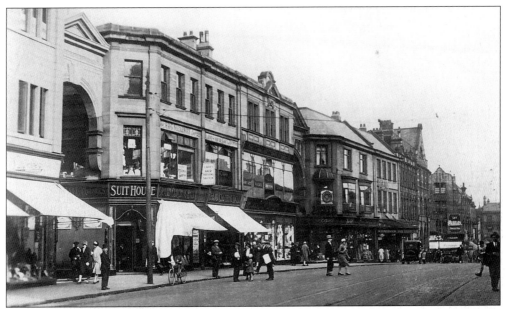

Northgate, early 1930s. The Grand Clothing Hall and the entrances to Queensway Arcade (nearest camera) and Kingsway Arcade are on the left.

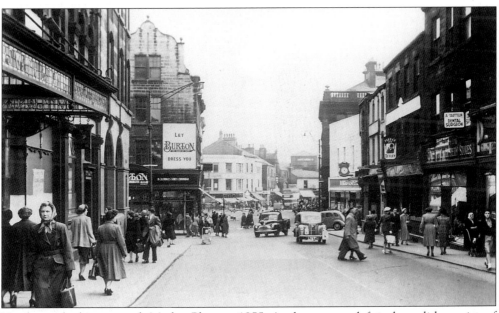

Northgate, looking towards Market Place, c. 1955. At the extreme left is the stylish awning of W.H. Smith's bookshop and newsagency. The Fleece Inn is on the right.

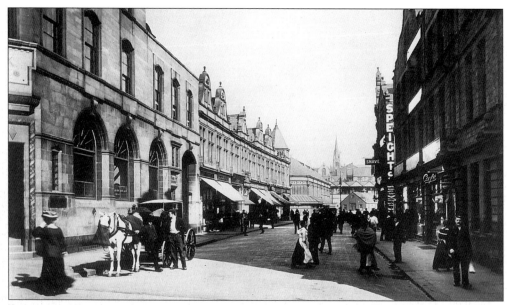

Corporation Street, *c.* 1908. The Union of London & Smiths Bank is at the left.

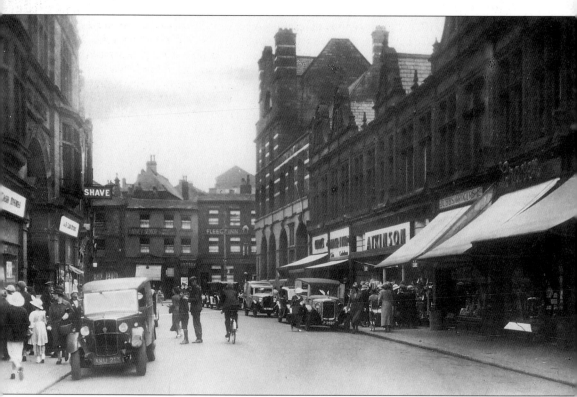

Corporation Street, looking towards Northgate, *c.* 1936.

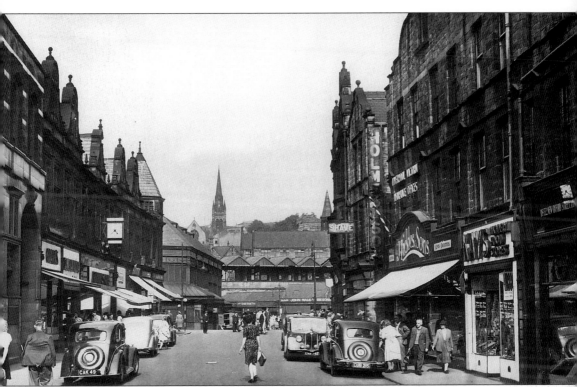

Corporation Street, *c.* 1938. In the second half of the last century, it replaced a narrow alleyway called New Bridge Street. The three cars whose registrations can be read were licensed in 1936-37. Parking, it seems, was not a problem in those carefree days before the war. Contrasting with the old soot-grimed buildings, some of the newer shop fronts have a sparkling 1930s look. The clock on the right, above Montague Burton's window, is a reflection of the one on the left above Atkinsons, ladies outfitters. In the distance, parts of the Covered Market, Central Station and St Philip's Church are visible, the last two having since been demolished. The barber pole and shaving sign belong to the Holmes & Son hairdressing establishment.

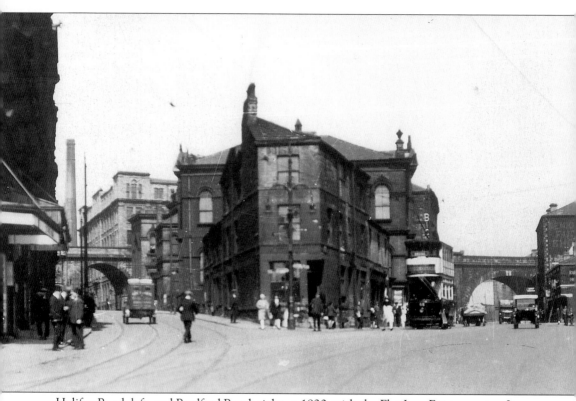

Halifax Road, left, and Bradford Road, right, *c.* 1920, with the Flat Iron Estate, centre. It was so called because of its shape. Mark Oldroyd's Spinkwell Mill is visible beyond the railway viaduct. The Railway Hotel is at extreme right. Some of the buildings on the Flat Iron Estate, but not Salem United Methodist Chapel behind, were demolished to make way for the new Corporation Gas showrooms, which were opened on 12 September 1932 by Alderman F.H. Dwyer. Public lavatories were installed in front. The 1930s were a time of change for Dewsbury.

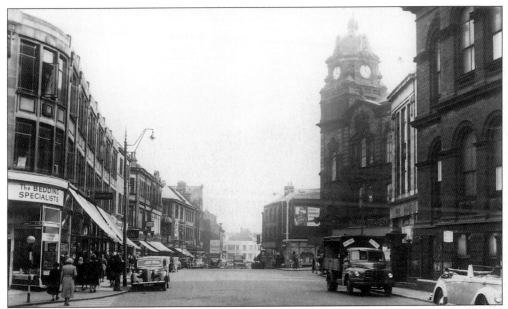

Northgate, *c.* 1955. Beyond the Gas showrooms, right, is the millinery and drapery department of Dewsbury Pioneers' Industrial Society. The foundation stone for these new central premises, with clock tower, was laid in 1878. The block of shop units with showrooms, left, was erected *c.* 1930.

Shops and showrooms seen in the upper picture under construction, with Northgate on the right.

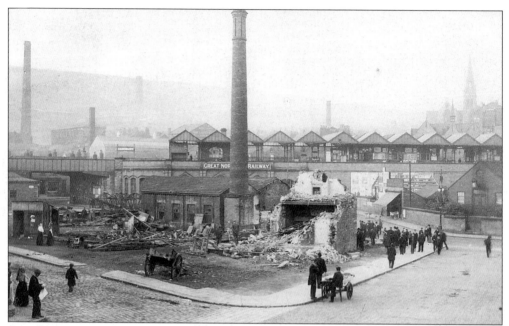

Site clearance for the Covered Market, 1903. The lower end of Corporation Street is on the right, with Crackenedge Lane running past Central Station towards the railway bridge. The Covered Market, with wholesale and retail facilities, was opened on 23 July 1904.

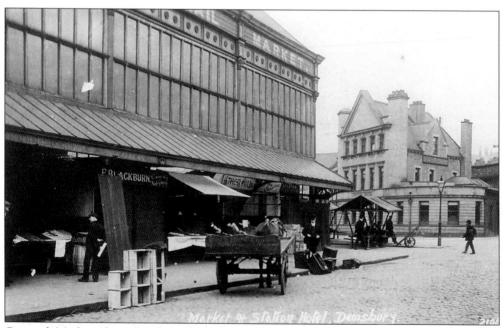

Covered Market, from Crackenedge Lane, shortly after opening. In the centre is a cart belonging to Fred Blackburn, fruit and vegetable merchant.

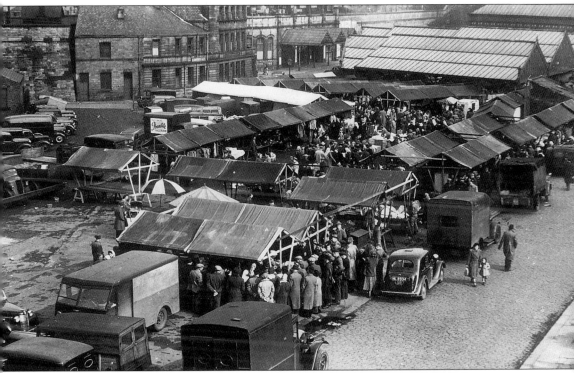

The Market, *c.* 1948. The Covered Market is in the background, right. Cloth Hall Street is in the foreground. With progressive development throughout this century, the town's traditional-style market has become one of the finest in Yorkshire.

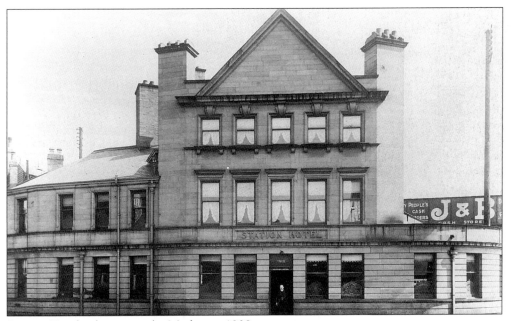

Station Hotel, adjacent to the Market, *c.* 1908.

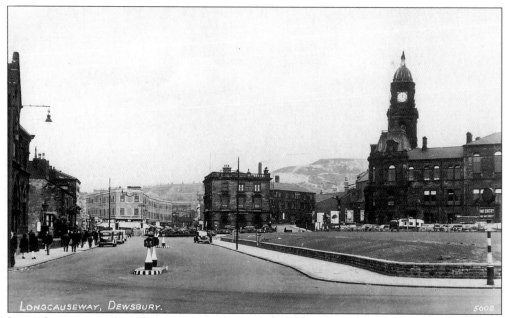

Long Causeway. After closure to passengers in 1930, Market Place Station was sold to Dewsbury Corporation in 1937 and demolished during 1938-9. The cleared site is on the right.

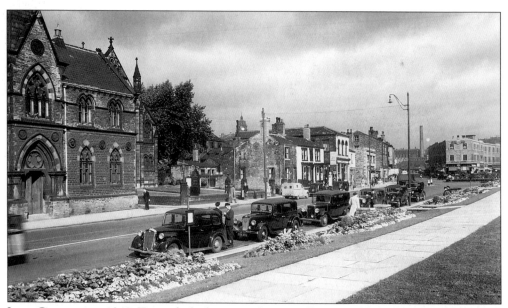

Long Causeway, c. 1948. Taxis ply for business; the taxi office is visible beside the petrol pump. Although the gardens remain, most of the buildings to the left have been demolished.

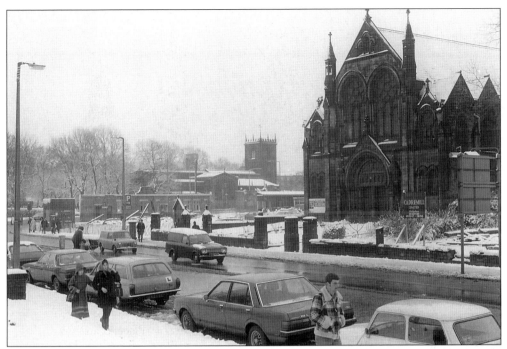

Long Causeway, February 1980, with the Parish Church and United Reformed Church. Between them, the old bus station site is being cleared in readiness for building the Princess of Wales Precinct.

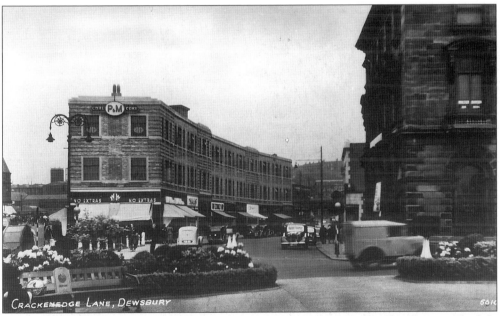

Crackenedge Lane, 1940s, from the front of the Town Hall. The block of buildings on the left, called Broadway House, was another 1930s development, being the first major brick structure in the town. Gents' tailors Weaver to Wearer occupy the end shop, with coal merchants Pearson & Moody above.

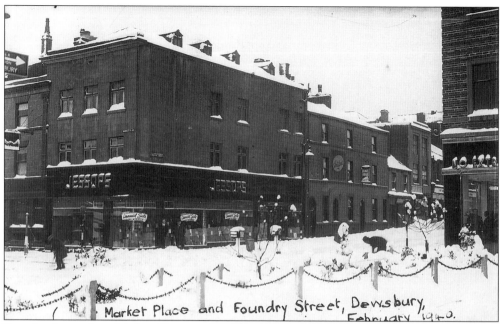

Foundry Street from Market Place in the February 1940 snowfall. Jessops (Tailors) Ltd, who specialised in men's and boys' clothing, was founded in Batley in 1854.

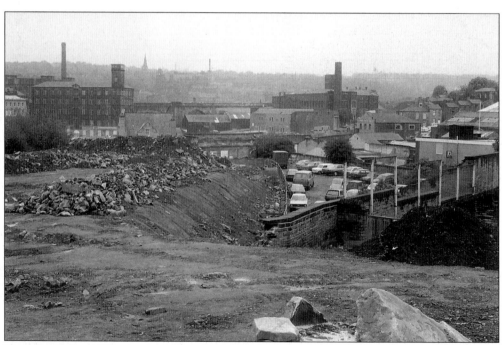

Ring Road site, 1980. At the time, it resembled a lunar landscape. Machell's and Spinkwell Mills are on the left.

Two
The Outskirts

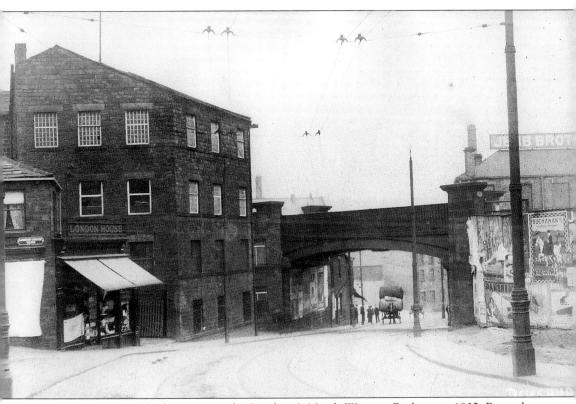

Webster Hill and the bridge carrying the London & North Western Railway, *c.* 1905. Beyond the adverts (one for Panshine), the woollen rag warehouse of Judd Bros. is visible. On the left is London House Yard and the London House Drapery store.

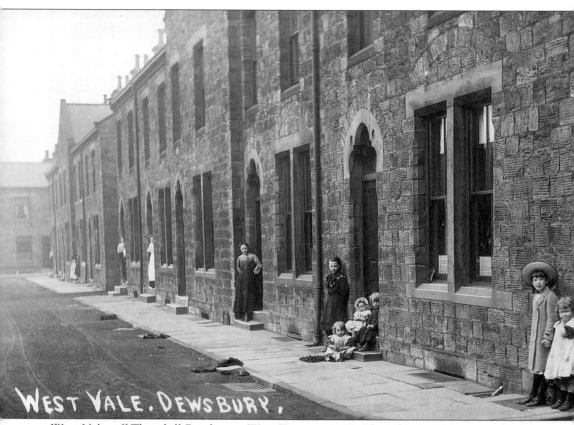

WEST VALE. DEWSBURY.

West Vale, off Thornhill Road, near West Town, *c.* 1905. These houses were constructed for mill workers, *c.* 1873. Although back-to-back type, with no through air flow, they look robust. Decorative arches over ground floor windows give extra strength above the lintels. Large sash windows permit reasonable light and ventilation, whilst door fanlights allow extra light. Each house had a ground-floor room, two bedrooms and a cellar, the latter with a grated window and metal coal door. The houses have been converted to through-type. Daw Green was the earliest 'suburb' of Dewsbury, with almost as many residents as the town itself. Communities eventually sprang up in areas such as Batley Carr, which is partly within Dewsbury, and West Town. The residential part of Savile Town (originally a constituent of Thornhill Urban District) was a later development, its industry being confined to the riverside area. Many of the early houses in West Town and Batley Carr were back-to-back terrace type, but those in Savile Town were mainly through terrace houses.

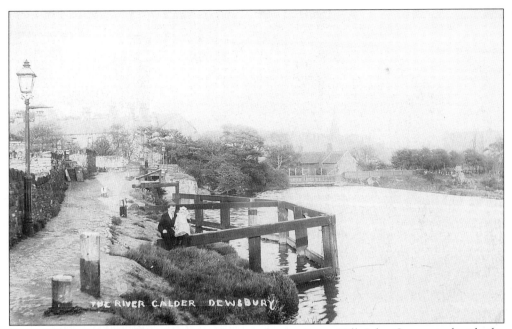

River Calder, *c.* 1905, taken from near the aqueduct at Scout Hill. John Carter sits beside the (probably polluted) water, with Island View in the background.

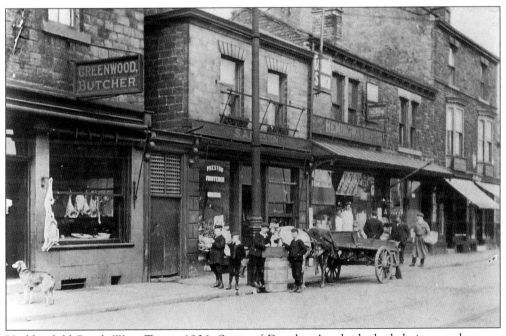

Huddersfield Road, West Town, 1906. Some of Dewsbury's suburbs had their own shops, as exemplified here by: Fred Greenwood (butcher), S.A. Preston (fruiterer), Hemingway Bros. (grocers). The latter shop advertises a public telephone.

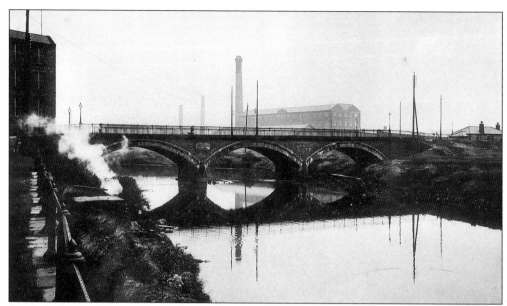

Savile Bridge, *c.* 1912. Crossing the River Calder, this stone bridge of three arches was opened on 10 March 1863. The bridge was reopened on 2 December 1936 after widening and reconstruction.

Savile Road, *c.* 1912, with the cricket and recreation ground on the right. To connect the Savile Estate with Dewsbury, this broad road was constructed from Savile Bridge to Thornhill Station. It was opened in March 1863. Houses and shops were built on much of its length.

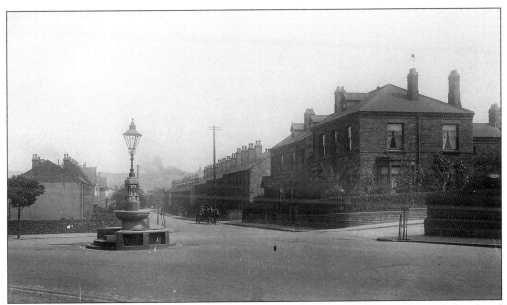

Fountain, Savile Town, *c.* 1910. Savile Road is in the foreground, Warren Street behind and Headfield Road on the right.

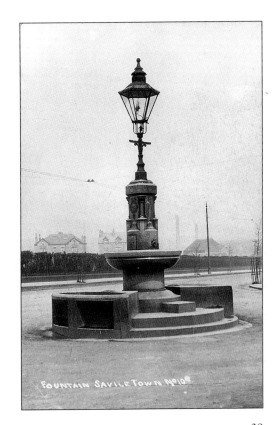

Fountain, Savile Town, *c.* 1902, with the recreation ground behind. It incorporates water receptacles at three different levels – for dogs, horses and humans. It was erected by the Right Honourable John Baron Savile GCB in 1894.

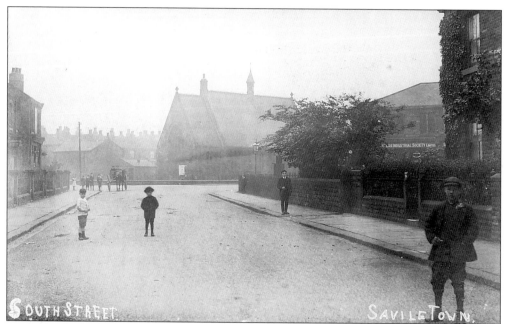

South Street, Savile Town, *c.* 1910. The mixed and infants Church of England school, centre, was erected in 1870 to take 283 pupils. To the right is a branch of Dewsbury Pioneers' Industrial Society.

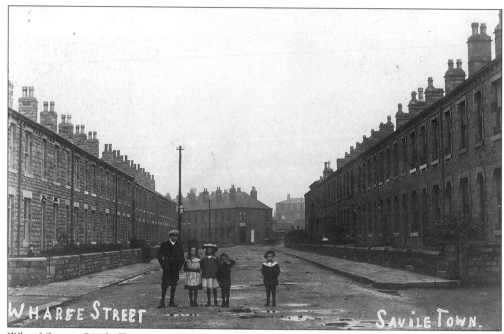

Wharf Street, Savile Town, *c.* 1909. These through houses, with yards at the rear, have small gardens at the front. The houses on the left are almost new.

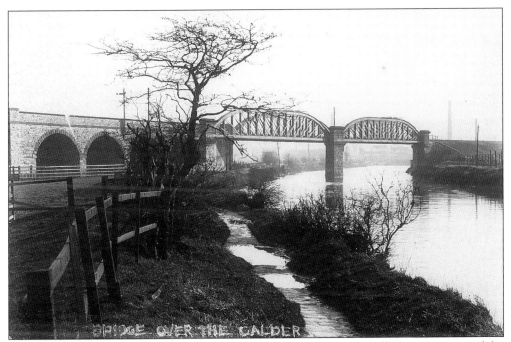

River Calder, near Savile Town, *c.* 1910. The masonry bridges and girder spans are part of the Headfield Spur, opened in 1887 by the Great Northern Railway from Headfield Junction (near the chemical works at Savile Town) to Dewsbury Junction. To obviate flood danger, the spur was built on embankments.

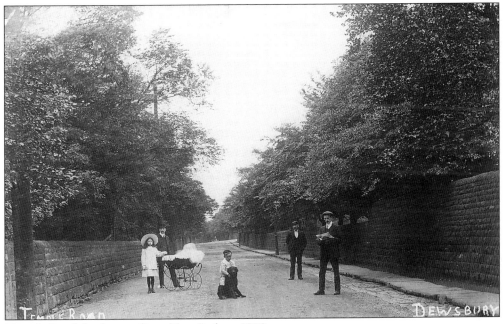

Temple Road, leading to Crow Nest Park, *c.* 1910.

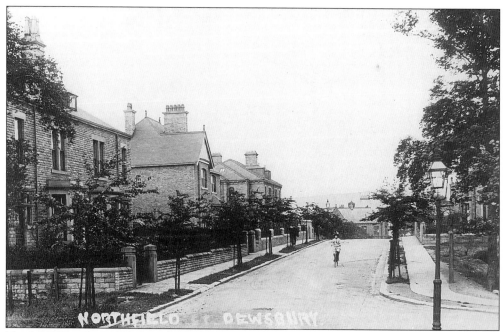

Northfield Road, *c.* 1908. Dewsbury's elite suburbia was north of the town, on higher ground to the west of Halifax Road. These splendid dwellings in Northfield Road, which runs into Halifax Road, boast bay windows, attic skylights, walled and railinged front gardens, with saplings on the verges.

West Park Street, *c.* 1908, which also runs into Halifax Road. On the right are better type terrace houses and semidetached villas. St Mark's Church, erected in 1865, is in the distance.

Three
Schools, Churches and Hospitals

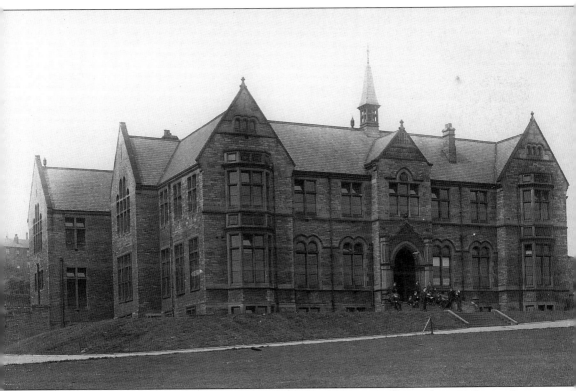

Wheelwright Boys' Grammar School, Halifax Road, *c.* 1913. It was opened on 18 September 1889. The nearby Wheelwright Girls' Grammar School was opened on 29 May 1933. Extensions to the boys' school were completed early in 1937.

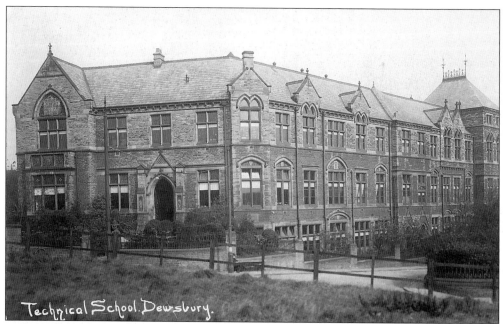

Technical School, Halifax Road, *c.* 1913. It opened on 12 June 1890. The basement incorporated joiners' and plumbers' shops, cookery and laundry kitchens, a mechanical laboratory, textile rooms and a commercial room. The ground floor included physics and biology labs, various classrooms and offices. The upper floor was allocated to art studies, with modelling and life rooms, a lecture theatre and various classrooms. Extensions to engineering and textile departments were completed in 1934.

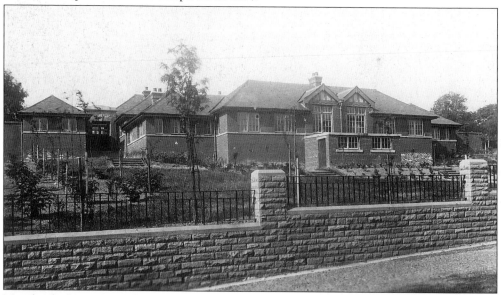

Moorlands Open-Air School, soon after opening on 8 May 1929. It was built when many children still lived in squalid conditions and suffered from rickets or tuberculosis. School and grounds were designed to provide children with maximum benefit from fresh air and sunshine. Accommodation was for 100 medically selected youngsters, aged six to thirteen. It was demolished after about forty-five years.

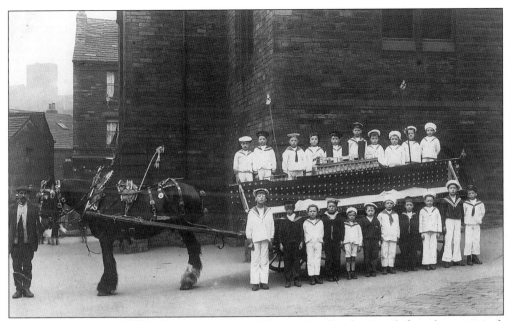

Eastborough Council School, Battye Street. The nautically decorated float bears a craft appropriately named SS *Eastboro*. The shire horse and dray were loaned by Machell Bros., local mungo and shoddy manufacturers. Mums and teachers must have been busy, and the children, no doubt, loved it.

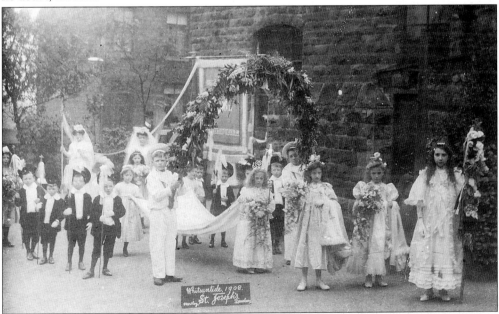

The May Queen and retinue of St Joseph's Catholic School, Naylor Street, Whitsuntide 1908. The Queen, centre, is Mary Catherine Mann, wearing a dress of cream silk brocade and crown of pearls. Her bower is supported by Frank Cullen and J. Thornton in sailor suits. Eight boys in brown velvet suits with Eton collars form a bodyguard. In front is Dolly Love carrying a floral wand. The group took part in a procession which toured the area, led by the Cleckheaton Temperance Band.

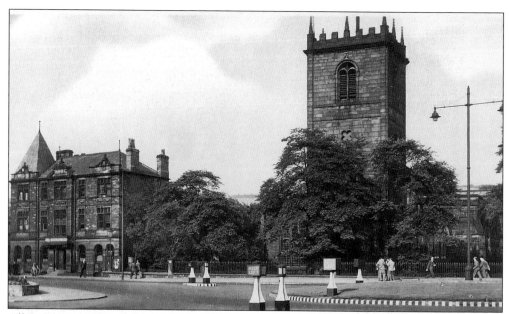

All Saints' Parish Church and Church House from Wilton Street, *c.* 1950. Parts of the church go back to the twelfth century, but most of it is less ancient. The present tower dates from 1767. Church House, left, was demolished for road widening.

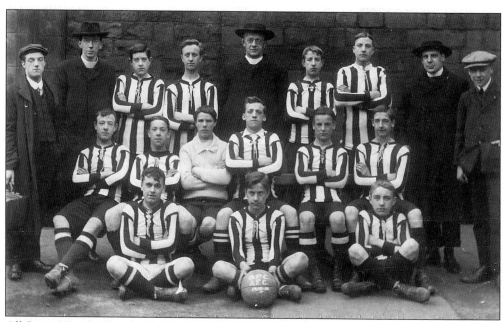

All Saints' Parish Church Sunday School football team, 1910-11.

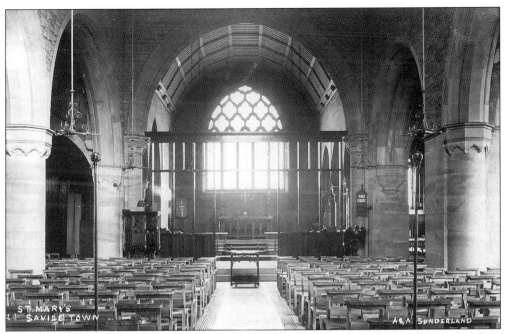

Parish Church of St Mary the Virgin, Savile Town, 1904. Replacing an older mission church, it was built on a site presented by Lord Savile, and consecrated on 30 June 1900.

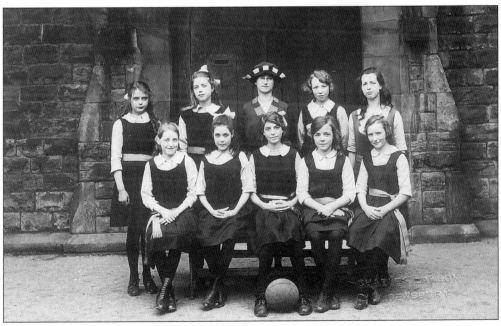

St Mary's Parish Church, Savile Town, netball team, 1921.

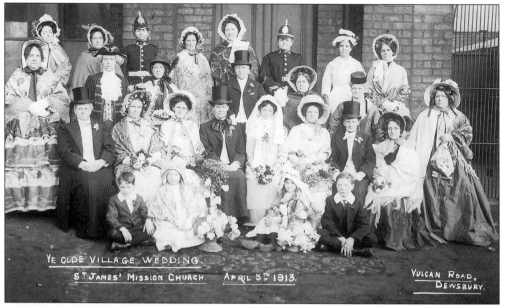

'Ye Olde Village Wedding', St James' Mission Church, Vulcan Road, 5 April 1913. This oft-performed money-raising entertainment was relatively easy to produce. Proceedings usually began with dialogue by village gossips and a 'wedding' procession. These were followed by a concert of individual items by the wedding party and sale of bridal cake. Try to pick out the bride, groom and gossips!

Our Lady and St Paulinus Roman Catholic Church, Huddersfield Road, c. 1910. The architect was E.W. Pugin, son of the more famous A.W. Pugin. The foundation stone was laid in 1867 and the building finished in 1871. Previously, a rented room was used for worship. The nearby St Paulinus School was opened in 1899 to replace an earlier school. Some of the classrooms incorporated glass cases which were filled with items for object lessons.

Primitive Methodist Chapel, Wellington Road. It was built in 1865-6 amidst much fundraising, including a bazaar in the lecture hall of Dewsbury Wesleyan Literary Society on 23 April 1866. The card was posted in 1904. Of three Methodist Chapels near the town centre, only Central (formerly Centenary Wesleyan) on Daisy Hill remains in use, its obsolete gallery having been sealed off. The Salem United Methodist building (originally Methodist New Connection) languishes on the Flat Iron Site.

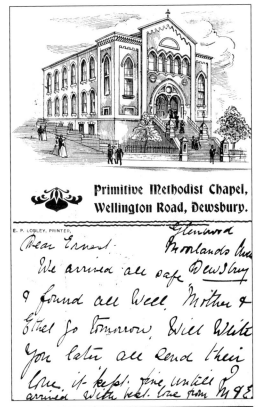

Primitive Methodist Chapel, Wellington Road, Dewsbury.

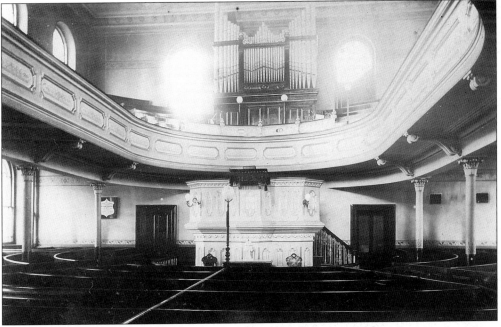

Primitive Methodist Chapel, Wellington Road, *c.* 1908. Preaching and singing were important elements of Methodist worship. This explains the prominence of the pulpit, organ and choir stalls (in front of the organ).

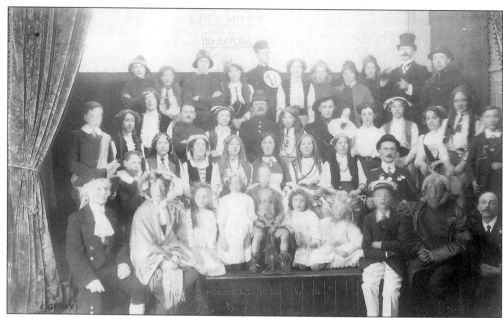

Ebenezer Choir in *Agatha*, 15 April 1913. The cantata was performed in the schoolroom, with Sir Mark Oldroyd presiding. Ebenezer Congregational Chapel was built on Long Causeway in 1883-4. It was later called United Congregational, and became the United Reformed Church in 1972.

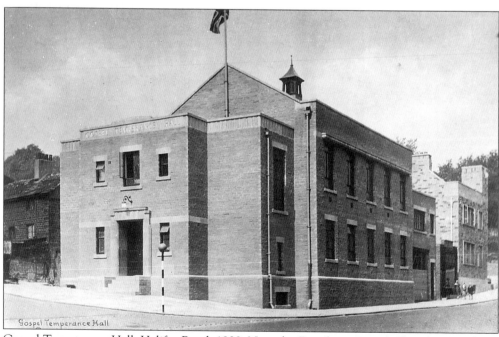

Gospel Temperance Hall, Halifax Road, 1939. Now the Dewsbury Gospel Church, it was built in 1938-9, to replace the Temperance Hall in Foundry Street, which was demolished for road improvements.

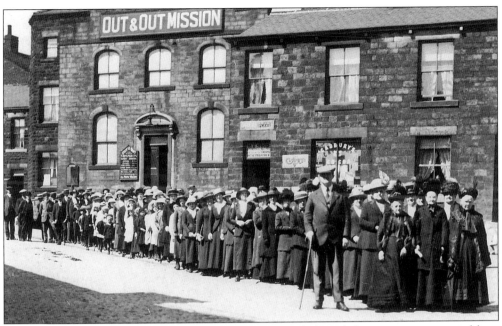

Out and Out Mission, Crackenedge Lane, *c.* 1910. It is believed the mission was started by a group of disgruntled Methodists who wished to reach out to the poor of the area.

Out and Out Mission, Crackenedge Lane. By the 1960s, it was known as the International Gospel Mission. The building was later purchased by a group of Christians who were meeting in the Social Centre for the Disabled, and reopened on 8 July 1983 as the Dewsbury Evangelical Church. The space inside the building, which once had a gallery, was converted to two floors to suit today's need, but some fine wooden beams are still extant in the roof.

Out and Out Mission,

CRACKENEDGE LANE, DEWSBURY, YORKS.

························

Induction of the New Pastor, the Rev. Henry Lawson Smith.

························

SATURDAY (D.V.) AUGUST 18TH,

DIVINE WORSHIP AT 3-15 P.M.

PREACHER :

The Rev. Herbert W. White

(The Modern George Muller),

DIRECTOR OF THE CHILDREN'S HOME AND MISSION, LONDON.

FAITH TEA & TABLE CONFERENCE AT 4-45.

Induction Service at 6-30.

CHAIRMAN - COUN. F. W. THOMPSON.

Speakers - Rev. H. W. White,
Rev. C. H. Brown, Rev. H. Lawson Smith
and Others.

A HEARTY WELCOME TO ALL !

H. Lodge & Sons, Printers, Dewsbury.

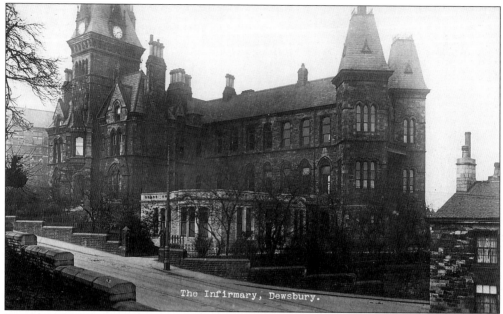

The Infirmary, Dewsbury.

Dewsbury and District General Infirmary, Halifax Road, *c.* 1920. Replacing the Cottage Hospital in Northgate, the General Infirmary was opened in 1883 by the Mayor of Dewsbury, Alderman William Machell. It was enlarged in 1909, when a nurses home was added. After completion of a new infirmary in Moorlands Road, it became the Municipal Building.

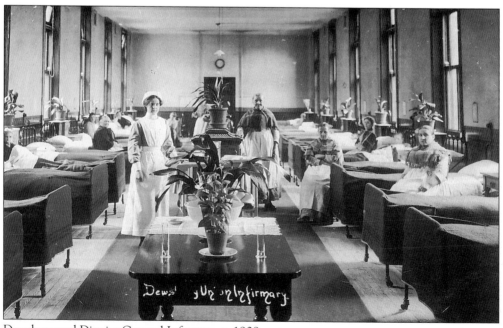

Dewsbury and District General Infirmary, *c.* 1908.

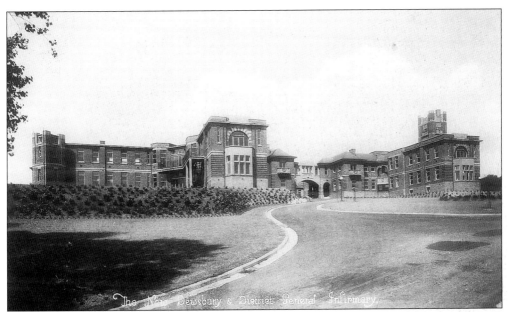

New Dewsbury and District General Infirmary, Moorlands Road, shortly after opening on 13 September 1930. The hospital incorporated all the most up-to-date equipment. It accommodated over 100 patients, including private rooms for ten paying patients. It was demolished in July 1994 after completion of another new Dewsbury and District General Infirmary in Healds Road.

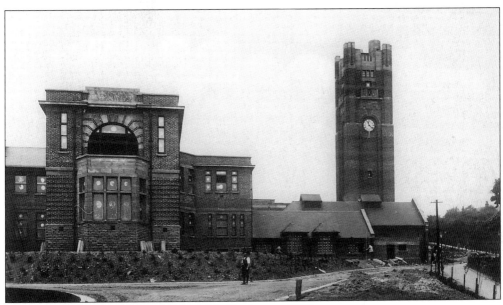

New Infirmary, nearing completion, probably August 1929.

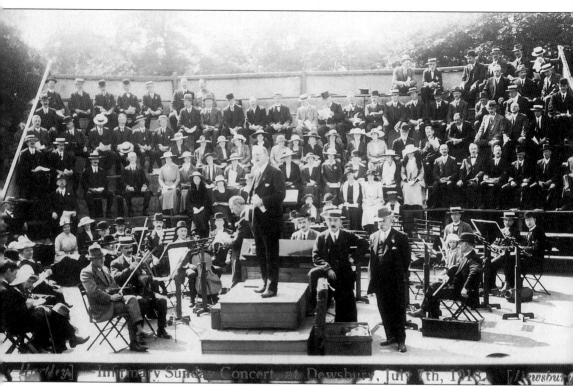

Infirmary Sunday Concert, Crow Nest Park, 7 July 1918. The conductor, Mr Ward Kemp, stands on the podium at this, the thirty-ninth annual concert. The programme included items from *Messiah* and five hymns for the audience to join in. The infirmaries were largely maintained through contributions from rich and poor, and by various fundraising events.

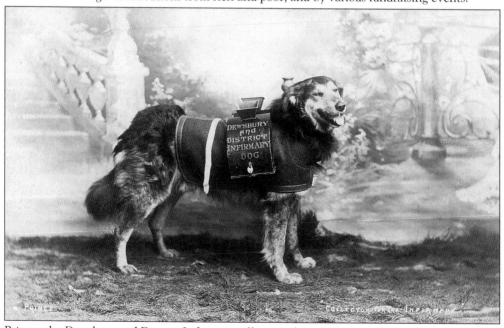

Prince, the Dewsbury and District Infirmary collecting dog, 1904.

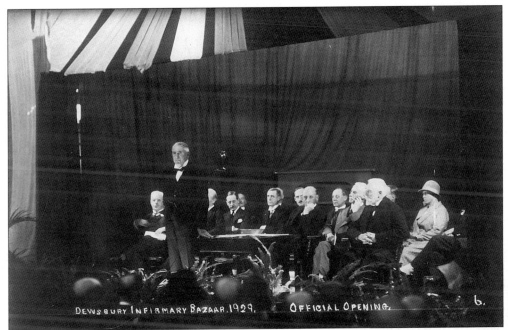

Infirmary Bazaar, Tuesday 15 to Saturday 19 October 1929. Lord Moynihan, President of the Royal College of Surgeons (standing) opens the mammoth event at the new Dewsbury Infirmary on the Tuesday.

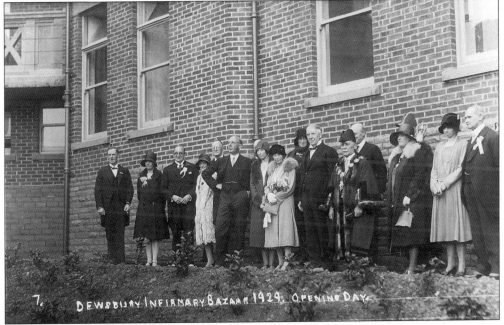

Infirmary Bazaar, October 1929. Included in this mayoral party on the first day are the opener, Lord Moynihan, and chairman, Mr L.R. Braithwaite, a renowned local surgeon (sixth from left). Other notables acted as chairmen and openers on subsequent days. Numerous entertainments and competitions were held throughout the event, and tea, supper, rest and smoke rooms were provided. In all, over £22,000 was raised for the new building.

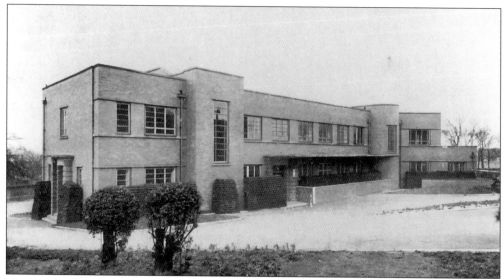

Moorlands Maternity Home, 1940. With space for twenty-seven beds, it was officially opened on 1 April 1940. Expectant mothers paid according to their means. The booking fee was 5/-. Charges ranged from 2/- to 10/- per day. Dewsbury residents paid five guineas a week for a private ward; non-residents seven guineas. A separate new building housed the ante-natal clinic.

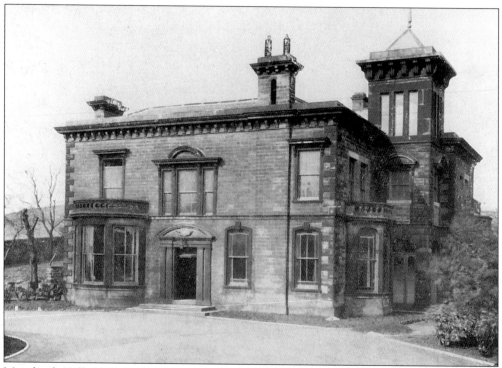

Moorlands Hall, 1940. It served as a maternity home from 1924 to 1940, when it was converted to a home for eleven nursing staff and four resident domestic staff. It also housed the kitchen, which had an Aga cooker and an electric dishwasher. Food was taken across to the ward block in an electrically-heated insulated container.

Four
Industry and Trade

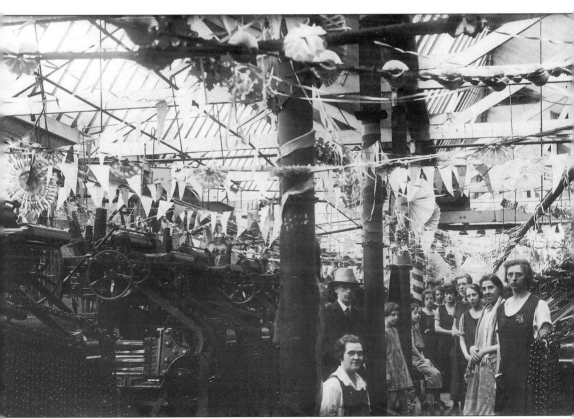

Decorations in a Dewsbury weaving shed. The exact location and event are unknown.

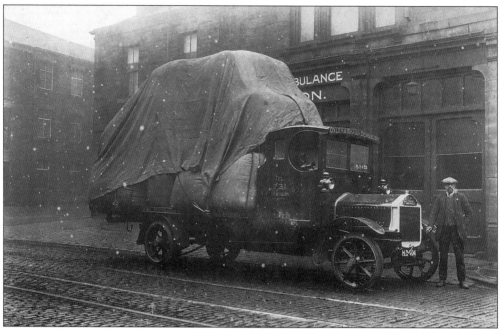

Oxley & Sharp Ltd, rag merchants of Cut End Mills, Savile Town. Their lorry, on which the words 'mungoes' and 'shoddies' are just visible, is laden with bales of rags. It is parked outside Batley Ambulance Station, where Well Lane joins Bradford Road.

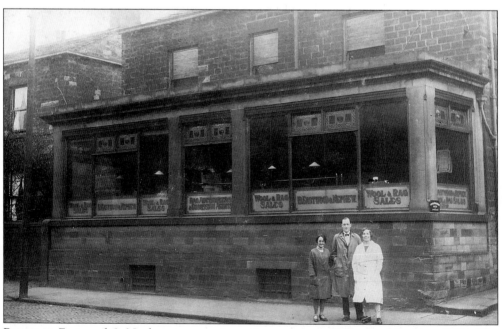

Benjamin Eastwood & Nephew, rag auctioneering premises, 52 Bradford Road, *c.* 1930. The firm, established in 1857, had other warehouses in nearby Greaves Road, Wood Street and Bradford Street. The building now forms part of Chadwick Lawrence, solicitors.

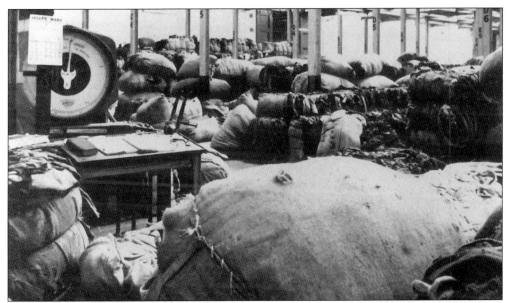

Robert Thornton & Sons (Dewsbury) Ltd, rag warehouse, c. 1959. In 1877, Thornton acquired his first premises, a three-storey building in Wilton Street, for rag warehousing and auctioning. The firm moved to purpose-built premises in Savile Town in 1915. Offices were located at the front. Part of the huge warehouse is shown. Large sliding doors on one wall allowed for receipt and despatch of bales. Further rags were stored in the basement.

Henry Cullingworth & Sons (Dewsbury) Ltd, part of rag auction catalogue, 1965. It comprises of 165 lots. Item 98 is one bale of grey worsted which fetched 85/-; items 108 is two bales of coffee serge and merino which went for 70/-. Dewsbury's fourth rag auctioneer was Joseph Eastwood & Co, Victoria Road.

S. Oddy

Catalogue of Sales by Auction
OF
Soft and Mungo Rags
at the SALEROOM
SOUTH STREET, DEWSBURY
WEDNESDAY, 3rd MARCH, 1965

HENRY
CULLINGWORTH
& SONS (DEWSBURY) LTD.
AUCTIONEERS
Directors:
J. J. Cullingworth, M.A., J.P.
S. J. E. Hanley, A. Summers, A. Schofield

See Conditions of Sale posted in the Sale Room

Telegraphic Address: "Cullingworth, Dewsbury"
Telephone No.: 906 (Three Lines)

At 9-30 a.m.

NO.7. WAREHOUSE.

```
              IXL
1..14  Jazz Knitt 1/7 74 1/6    ...
2.. 8  Middle Green Knitt 25/8 25/8
                               ...

              LB
3..13  Light Blue Knitt         ...
4.. 6  Mix Green Knitt          ...
5..17  Jazz Knitt               ...
6.. 2  Dark Red Knitt           ...

              GC
7.. 4  Fancy Knitt 878 762 779 797...

              LR
A. 9  Light Crse.              ...
8..15  Jazz Knitt               ...
9.. 2  Dark Brown Knitt         ...
```

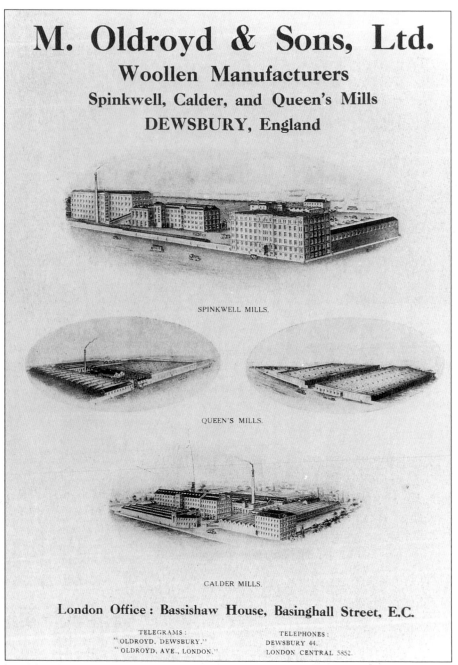

M. Oldroyd & Sons, Ltd.

Woollen Manufacturers

Spinkwell, Calder, and Queen's Mills
DEWSBURY, England

SPINKWELL MILLS.

QUEEN'S MILLS.

CALDER MILLS.

London Office : Bassishaw House, Basinghall Street, E.C.

TELEGRAMS :	TELEPHONES :
" OLDROYD, DEWSBURY."	DEWSBURY 44.
" OLDROYD, AVE., LONDON."	LONDON CENTRAL 5852.

Mark Oldroyd & Sons Ltd, woollen manufacturers, advertisement 1917. In 1817, Mark Oldroyd, a twenty-year-old Dewsbury man, started buying, spinning and weaving wool. By 1840, he owned a mill at Spinkwell. The firm became a limited company, Mark Oldroyd & Sons Ltd, which by the 1870s controlled several mills. One of the sons, also called Mark, became chairman of the company and was knighted in 1909. Spinkwell Mills were situated between Bradford Road and Halifax Road; Queen's Mills were on Mill Street East; Calder Mills were between the Parish Church and the river. All processes of woollen manufacture, from raw wool to finished cloth, were handled in the mills.

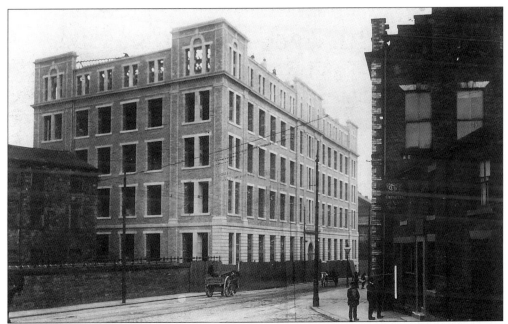

Mark Oldroyd & Sons Ltd, woollen manufacturers, extension to Spinkwell Mills nearing completion, c. 1911. At extreme right is the Corporation Inn. Most of the Spinkwell Mill complex, including several multi-storey buildings, extensive weaving sheds and a tall chimney, was demolished c. 1960. The above building was retained and is now partly occupied by F.A. South, furnishers. Much of the rest of the site accommodates the Safeway supermarket and car park.

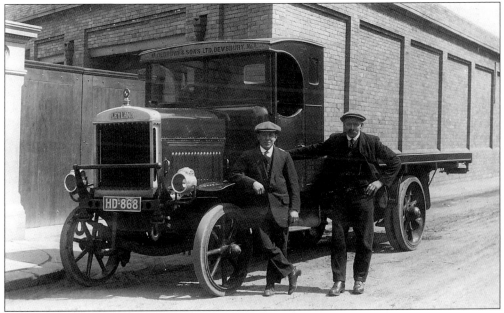

Mark Oldroyd & Sons Ltd, solid-tyred lorry, photographed in Savile Town.

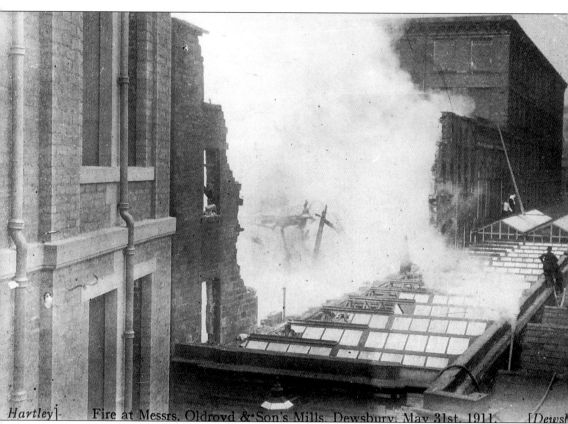

Hartley]· **Fire at Messrs. Oldroyd & Son's Mills, Dewsbury, May 31st, 1911.** *[Dews]*

Fire at Mark Oldroyd & Sons, 31 May 1911. It was discovered by Inspector Grice who was on duty in Halifax Road at one o'clock on Monday morning. He ran into Bradford Road and acquainted the mill's night watchman of the situation. A search confirmed that the oldest part of the complex, a four-storey building used partly for storage, was well alight. Dewsbury and Batley fire brigades arrived, but operations were hampered because no water was available in the mill yard, and had to be drawn from the mains in Bradford and Halifax Roads. Efforts were made to save the nearby engine house, but this was badly damaged. When workpeople arrived at 6 a.m., machines could not be started, and only men were allowed in to assist with reclamation. During the morning, George Dixon, spinner, Halifax Road, and Joseph Margetson, shaker, Earlsheaton, were buried when a wall collapsed. They were taken by horse ambulance to Dewsbury Infirmary, but Dixon died in the afternoon. Sir Mark Oldroyd, on holiday in Whitby, arrived later in the day. As well as considerable damage to the mill, vast stocks of material were destroyed. 700 of the 800 strong workforce were temporarily out of work. The old four-storey building is in the centre of the picture (shrouded in smoke). Weaving sheds, right, were partly damaged. The new building, left, in course of construction, was not affected.

Strike, Mark Oldroyd & Sons, February 1912. Caused by dissatisfaction over rates of pay, it affected Spinkwell and Queen's Mills. Ben Turner, prominent Labour supporter and secretary of the local branch of the National Union of Textile Workers, acted as mediator. After several days, the workers promised to resume work on Saturday at 6 a.m.. Some of the striking weavers are pictured at the Bradford Road entrance to Spinkwell Mill on 1 February. Shawls and boaters were familiar apparel.

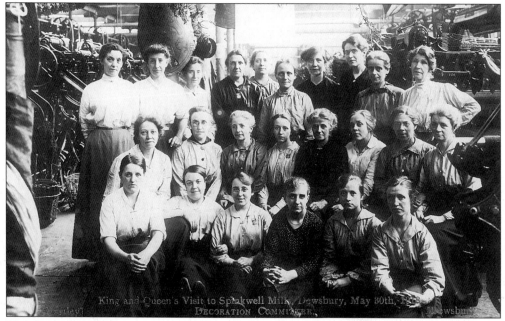

The King and Queen's visit to Oldroyd's Spinkwell Mills, 30 May 1918, featuring the decoration committee.

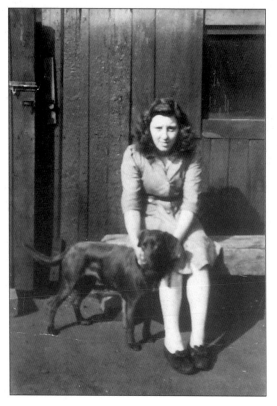

Phyllis Lister (née Abel), Mill Street East, Savile Town, in the mid 1940s. Aged fourteen, she commenced work as a stitcher (and tea girl) at the nearby Savile Mills of S. Ellis & Sons for about £1 per week. Starting time was 7.30 a.m., rather than the 6 o'clock of Edwardian days. Wearing mill apparel, she sits with a friend's chocolate labrador called Lady in a yard behind her home. It backed on to Victoria Mills, and was used by coal merchants Pearson & Moody. Hereabouts, the many mills and warehouses rubbed shoulders with the river, canal and railway to form the industrial heart of Savile Town. After two years, Phyllis, having become a weaver, moved to Mark Oldroyd's Spinkwell Mills. She still enthuses about the camaraderie at her Savile Town and Spinkwell workplaces.

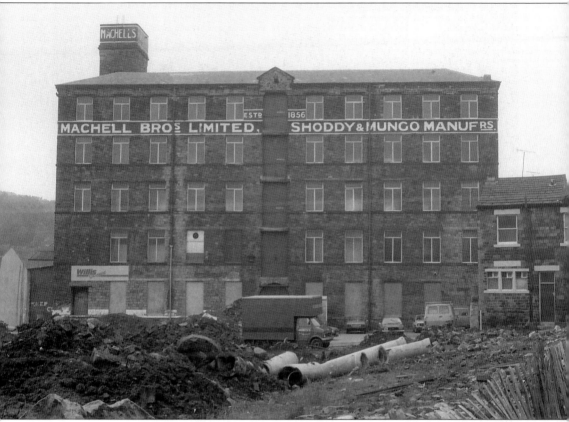

Machell Bros. Ltd, shoddy and mungo manufacturers, Cloth Hall Mills, Foundry Street. The building was erected in 1863 for R. & W. Machell. The photograph shows the mill in 1985 when the Ring Road was under construction (foreground). Note the doors for taking in rags at all levels of the mill. After being vacated by Machells, parts of the building were put to a variety of uses. In perpetuation of Dewsbury's past, the structure and its epithet still dominate the area at the end of the market. At mills such as Machells, rags were beaten and sorted by women employees, who removed the buttons, hooks and cotton threads. White rags were especially separated because of the their potential for either dyed or undyed end products. Afterwards, the rags were teased out in grinders. Reclaimed fibres were blended with new wool fibres in preparation for spinning and eventual weaving.

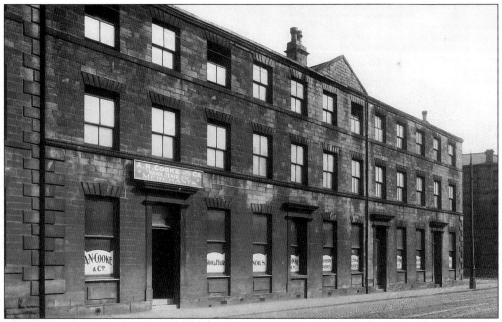

A.N. Cooke & Co, wool and waste merchants, 150 Bradford Road. Apart from sheep's wool and recycled material, other animal hairs were handled in the Dewsbury area. For example, Tibetan goats' hair was used to make Cashmere for shawls, whilst camels' hair was used in some tweeds. Observe the word 'noils' on one of the windows. During a process known as combing, long and short fibres were produced, known as 'tops' and 'noils' respectively. Noils were generally regarded as blending material, in a similar way to mungo and shoddy.

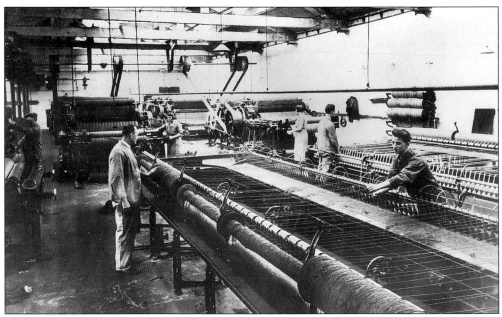

Yarn spinning for carpets in a Dewsbury mill, c. 1930. The actual location is unknown, but carpets and rugs were extensively made in and around the town.

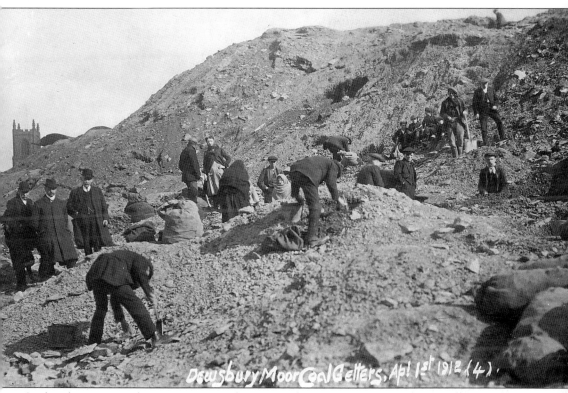

Coal picking at Dewsbury Moor, 1 April 1912. In that year, an estimated one million miners went on strike nationwide to obtain a guaranteed minimum wage. The strike began at the end of February and quickly affected pits in the Dewsbury area. This led to a shortage of domestic coal and the closure or part-time working of many local mills and factories. Those streets on the outskirts of town which depended on gaslight were put in darkness. Churches and schools provided meals for the unemployed and their dependents, especially children, and a soup kitchen was set up in the Town Hall. Men, women and children went searching for coal on pit waste tips at Shaw Cross and Dewsbury Moor, as depicted above. The spoil heap was attached to Conyers' Colliery, situated between Heckmondwike Road and Staincliffe Road. St John's Church is visible in the background. After receiving a reasonable offer from employers, and having considered the wishes of colliers, the National Council of the Miners' Federation of Great Britain, which met in London on 6 April, brought the countrywide strike to a close.

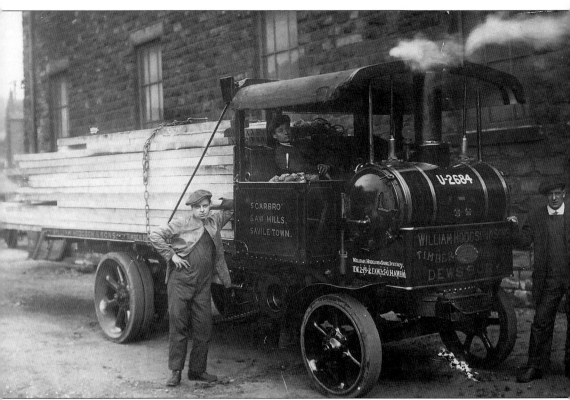

Steam wagon of William Hodgson & Sons, Scarborough Saw Mills, Savile Town, *c.* 1913. The firm, founded by William Hodgson, was later headed by sons William and John, before becoming a limited company. By the 1930s, the business had become a forerunner of today's do-it-yourself suppliers, with a range of doors, windows, mouldings, fencing, ladders, wheelbarrows etc. Large orders for housing schemes were also dealt with. The steam wagon has solid tyres and a speed limit restricted to 12 mph. It was manufactured by the Yorkshire Patent Steam Wagon Co, Leeds, who adopted the unusual design of having a double-ended boiler fitted transversely.

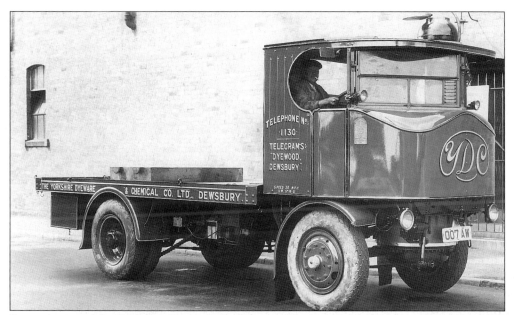

Steam wagon of the Yorkshire Dyeware & Chemical Co. Ltd, Calder Dyeware Mills, Thornhill Road, c. 1930. The firm supplied dyes, etc., for the textile industry. The wagon, still with trade plates, was made by Sentinel of Shrewsbury. It has pneumatic tyres and a speed limit of 20 mph. The vertical boiler is in front of the axle.

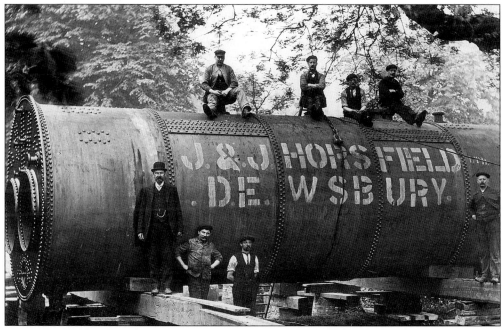

J. & J. Horsfield Ltd, Vulcan Ironworks, Vulcan Road. The firm was founded in 1828 by James and Joseph Horsfield for the manufacture of boilers. The specimen shown dates from c. 1905.

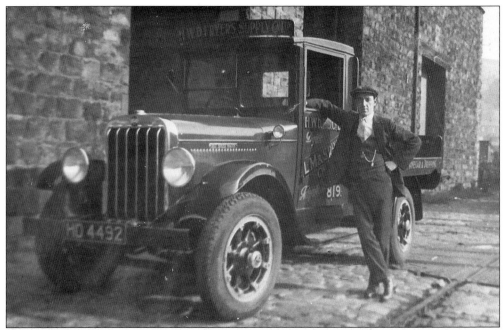

A lorry of the Heavy Woollen District Fryers' Supply Co. Ltd, whose address was Railway Street. The vehicle is parked against one of the LMS Railway warehouses adjacent to the street. Supplying the area's fish and chip shops with dripping and vinegar was a very important role.

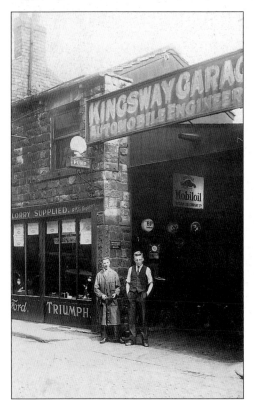

Kingsway Garage, Foundry Street, c. 1930. The young man is Harry Ormerod.

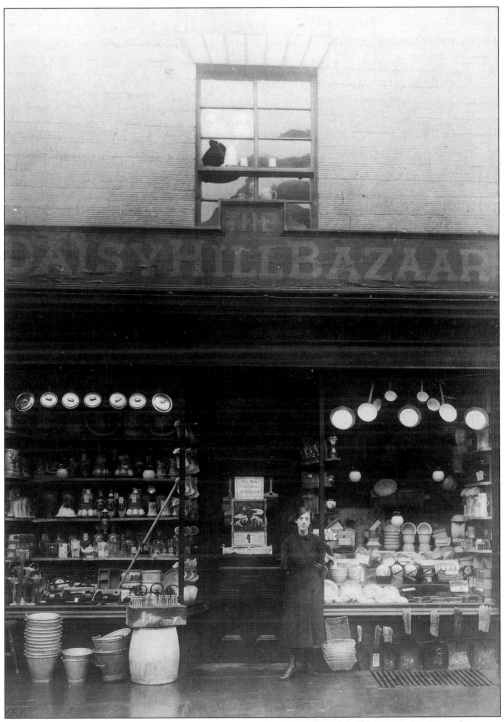

Daisy Hill Bazaar, *c.* 1928. It was established at the top of Daisy Hill by Laws & Co., who were rag merchants at Old Mill, Mill Road, off Bradford Road. Copper kettles, iron pans and zinc buckets were some of the lines available. Observe the peggy tub and coal scuttles on the pavement.

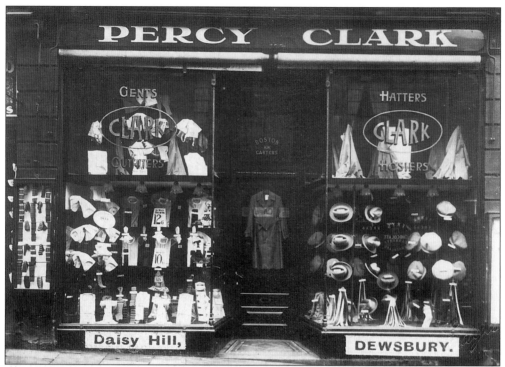

Percy Clark, gents' outfitter, hatter and hosier, Daisy Hill, in the 1920s.

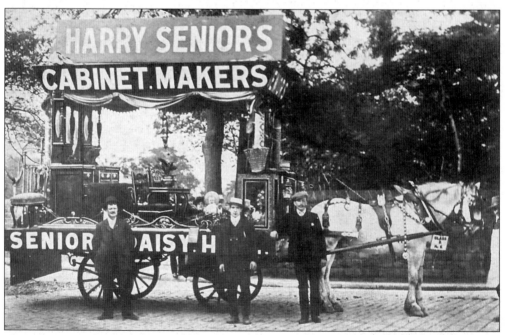

Harry Senior, cabinet maker and house furnisher, decorated float, *c.* 1905. The shops and showrooms at 44 to 52 Daisy Hill had areas laid out as dining rooms, parlours and bedrooms. 'Homes complete for £100' were on offer. There was a glass and china department, where matchings and repairs were also arranged.

W.W. Speights' ladies' and gentlemen's hairdressing salon and shop, 12 Corporation Street, *c*. 1910. By about 1914, the business belonged to Holmes & Son, who described themselves as 'medical electricians' in addition to hairdressers and perfumers.

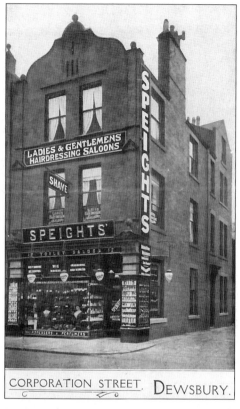

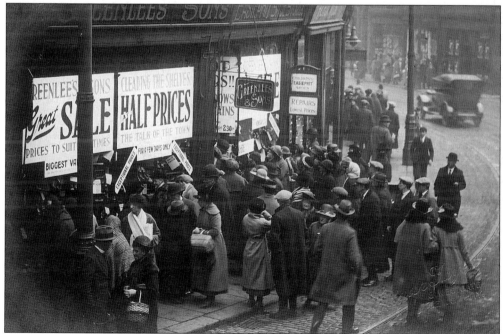

Greenlees & Sons, boot and shoe makers, 16 to 18 Westgate, in the 1920s. 'Easiphit' was their trademark.

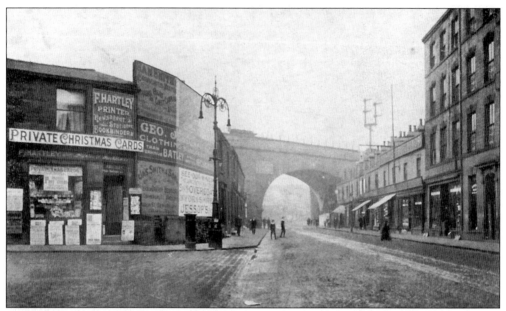

Fred Hartley's shop and printing works, c. 1905. Bradford Road passes under the railway bridge; Wellington Road is on the left. A keen photographer, Hartley recorded the town's streets and events, and printed the images on to postcards for sale in the shop. He moved premises several times. The firm finally closed in 1956.

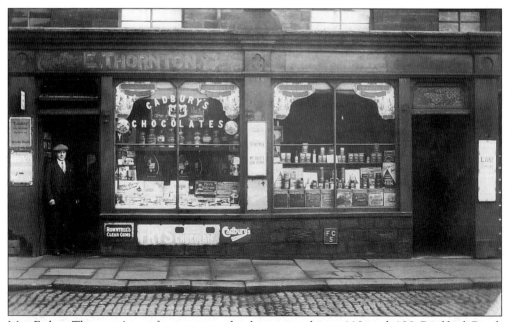

Mrs Esther Thornton's confectionery and tobacconist shops, 118 and 120 Bradford Road, c. 1912. The windows display a large range of goods, including sweets, biscuits and tea. For a time, Mrs Thornton also sold tripe at No 118, right. The buildings have been demolished.

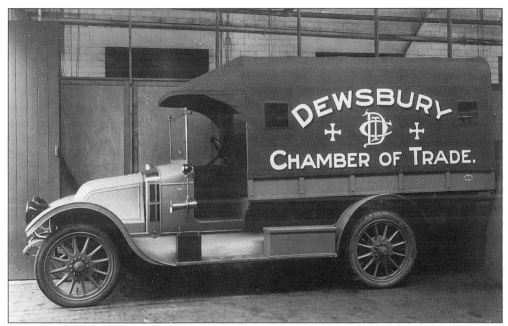

Dewsbury Chamber of Trade originated in 1881 as the Dewsbury and District Tradesmen's Association. It organised the annual Yorkshire Wool Queen contests (in conjunction with the *Yorkshire Observer*) and the Dewsbury Shopping Week events.

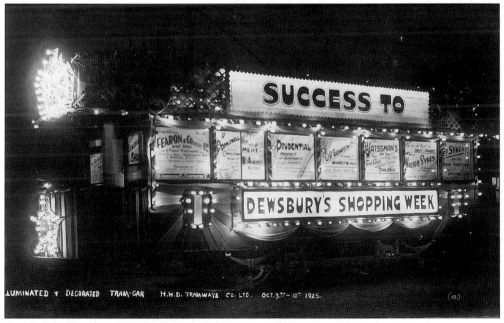

Dewsbury's Shopping Week, illuminated tramcar, 1925.

WELLINGTON R^D OPPOSITE L & N.W. STATION.

DEWSBURY July 190 7

EDGER F^o

D^R TO: **THE REPORTER LIMITED.**

PROPRIETORS
DEWSBURY REPORTER EST. 1858.
BATLEY REPORTER EST. 1866.
HECKMONDWIKE REPORTER EST. 1867.
MIRFIELD & RAVENSTHORPE REPORTER EST. 1881.

12 PAGES — 84 TO 92 COLS. ONE PENNY.

TELEPHONES - DEWSBURY. 245. BATLEY 36.
Manager – R. STAPLETON.

Cheques should be made payable to The Reporter L^{td}

Messrs. Haigh, Barker & Scholes. Solicitors, Dewsbury

DATE 1907						£	s	d
April		27	Sale of Property	re Tolson			5	6
May	4/11		" "	at Heck. & Dewsbury		2	4	.
						2	9	6

The Reporter Ltd, 1907 invoice. The building and the *Dewsbury Reporter* are still going strong. Haigh, Barker & Scholes, solicitors, operated from 12 Church Street.

Five

Leisure

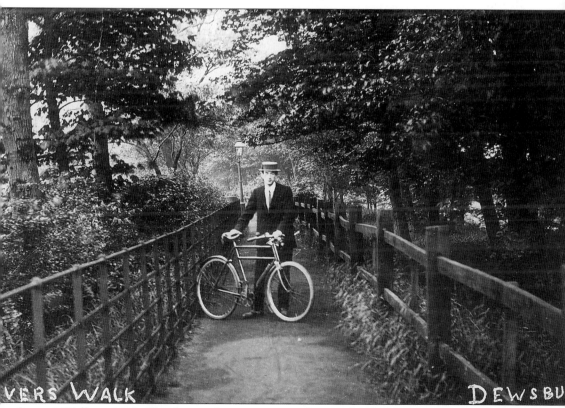

Lovers' Walk, *c.* 1912. This haven for courting couples, south of West Town and near the Calder, was not far from industry.

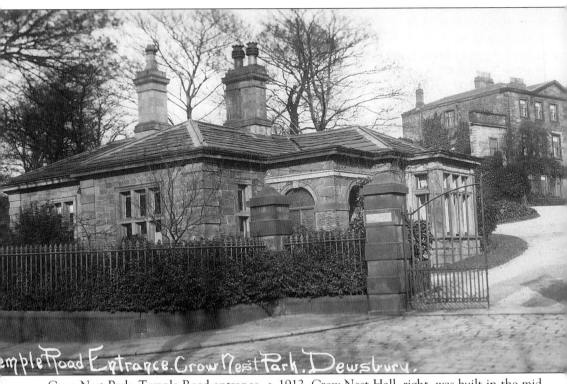

emple Road Entrance. Crow Nest Park. Dewsbury.

Crow Nest Park, Temple Road entrance, *c.* 1912. Crow Nest Hall, right, was built in the mid eighteenth century. Grounds and hall were purchased by John Hague, local industrialist and magistrate, early in the nineteenth century. Parts of the land were leased to local farmers. The estate later passed from the Hague family to their relatives, the Cookes. They negotiated its sale to Dewsbury Corporation in 1893 for over £20,000, with a similar sum being spent on laying out the grounds and converting part of the mansion to a museum. By the late 1890s, spectacular annual fêtes were held in the park. For the two-day event in August 1899, a large stage was erected at the foot of a slope on the east side. Artists at the shows, given twice each day, included: Halgro & Bartell (trapeze artists), Four Sisters Lee (acrobats), Rex Fox (high wire walker). The 1st Princess of Wales Own Yorkshire Regiment Band gave two performances each day. Chinese lanterns were festooned around the lake and on the mansion and bandstand. Firework displays brought each evening to a close.

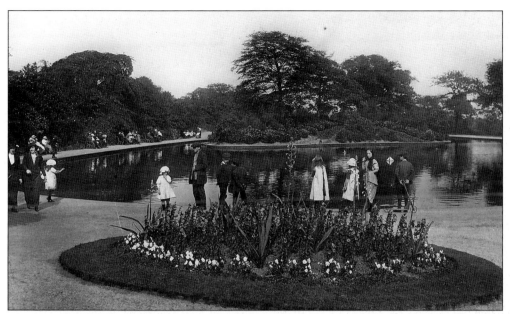

The lake, Crow Nest Park, *c.* 1910. William Daniels, parks superintendent for many years, designed the lake, with its island, fountain, and surrounding flower beds, rockeries and shrubberies.

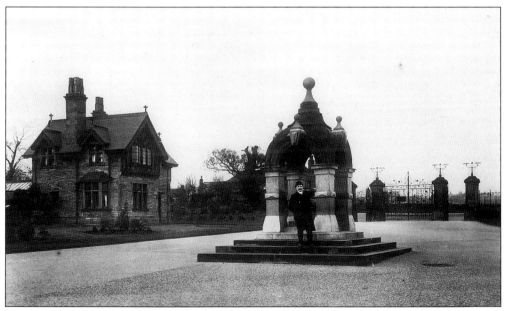

Drinking fountain, Crow Nest Park, *c.* 1912. Situated at the entrance from Boothroyd Lane, it was pulled down in 1924 to make way for the War Memorial.

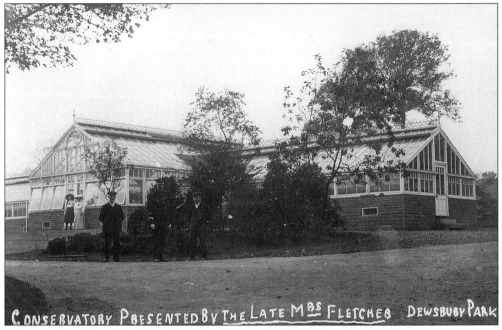

Conservatory, Crow Nest Park, 1912. It was opened on 13 November 1910.

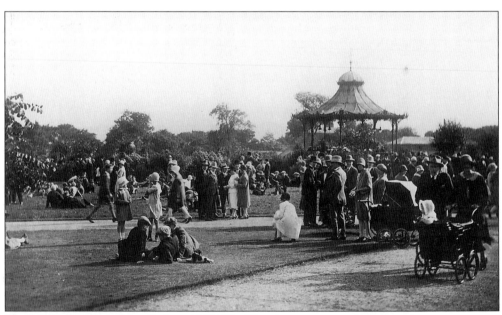

The bandstand, Crow Nest Park, *c.* 1932. The Tuesday evening and Sunday afternoon summer band performances were much enjoyed. Over the years, the town possessed several bands, including Dewsbury Borough, Dewsbury Old, Dewsbury Temperance and Dewsbury & District Military.

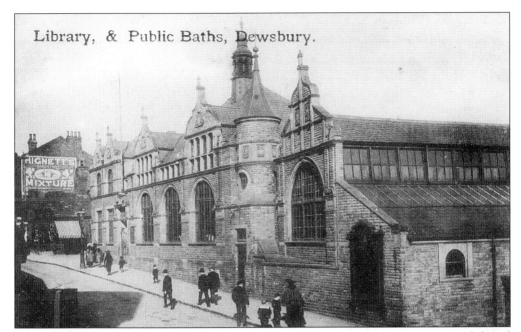

Library, Wellington Road, c. 1904. It was erected in 1896 and running expenses were defrayed by a penny on the rate. The baths were situated at the rear.

Public Baths. Situated in Old Westgate, they were also opened in 1896. The cover of a folder, probably issued in the late 1920s, is shown. It lists details and prices for mixed and separate bathing in the two pools. Slipper baths (the containers were shaped like slippers) were available for the many people with no bath at home. Use of a slipper bath with one towel cost 4d, with two towels at 5d. 'All towels are perfectly clean and sterilised for each person.' A pine foam bath cost 2/6 – a real luxury!

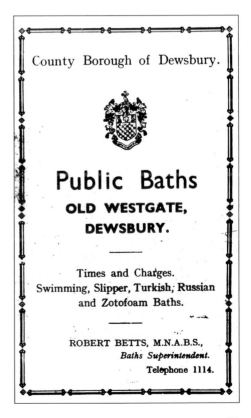

County Borough of Dewsbury.

Public Baths

OLD WESTGATE, DEWSBURY.

Times and Charges.
Swimming, Slipper, Turkish, Russian and Zotofoam Baths.

ROBERT BETTS, M.N.A.B.S.,
Baths Superintendent.
Telephone 1114.

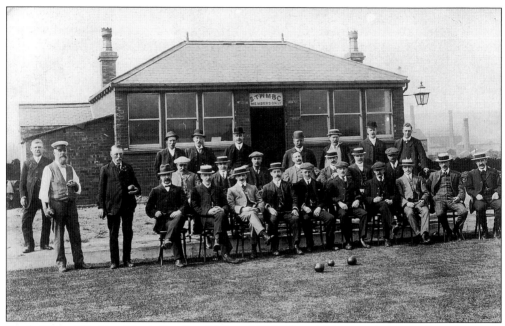

Savile Town Working Men's Bowling Club, *c.* 1906. This clubhouse was later enlarged.

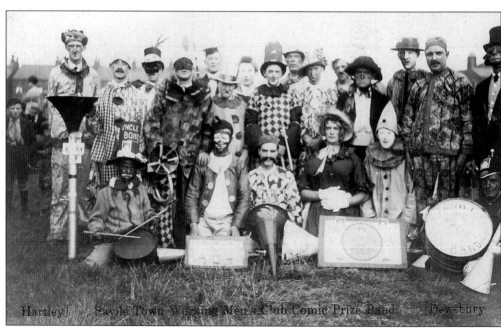

Savile Town Working Men's Club, Comic Prize Band, *c.* 1930. The instruments suggest that enthusiasm was more important than musical ability.

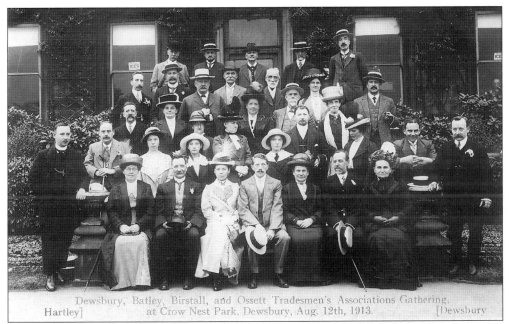

Gathering of Dewsbury, Batley, Birstall and Ossett Tradesmen's Association at Crow Nest Park, 12 August 1913. The ladies and gentlemen are posed in front of the mansion. Observe the ices notices for the ground-floor café.

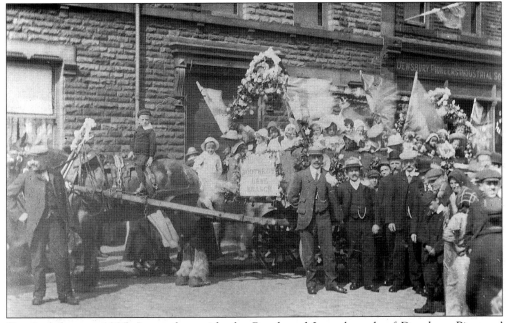

Carnival float, c. 1905. It stands outside the Boothroyd Lane branch of Dewsbury Pioneers' Industrial Co-operative Society.

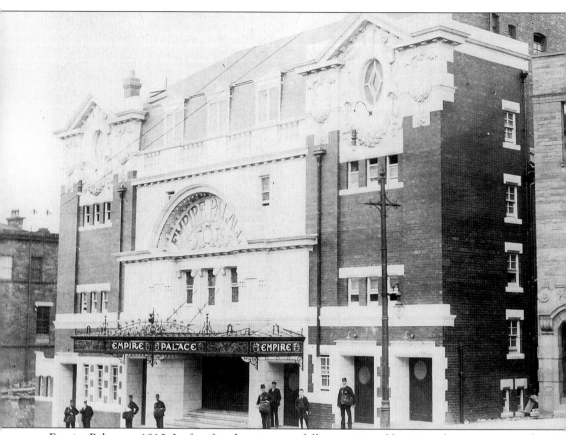

Empire Palace, *c.* 1910. Its fine façade was never fully appreciated because of propinquity to the Town Hall. The theatre closed for the last time in April 1955 and was demolished in 1961 to make way for a new shop and office block named Empire House. On the Empire's opening bill in 1909, a then little-known Robb Wilton appeared, along with a bioscope. A slightly better known Charlie Chaplin performed there shortly after. Music hall type entertainment was still popular after the Second World War. Among the comedians who played at the Empire in postwar years were Harry Bailey, Hilda Baker, Caryll & Munday, Charlie Chester, Bunny Doyle, Norman Evans, Cyril Fletcher, Nat Jackley, Albert Modley, Ken Platt, Terry Scott and Stan Stennett. Singers who topped various bills in the 1950s included Allan Jones, Josef Locke, Frankie Vaughan and Jimmy Young. Bill 'Witty Willy' Waddington, who was a comedian, appeared on the same programme as Betty Driver, then a singer, in September 1954. Other types of entertainment were presented. Anthony Newley acted in a run of plays presented by the Saxon Players during 1951, including *A Streetcar Named Desire*. Phyllis Dixey starred in *Peek-a-Boo* in July 1954. The 1954-55 pantomime *Babes in the Wood* featured Joe Black and the Musical Elliotts.

Empire Palace, *c.* 1930. Its main rival was the Hippodrome in Foundry Street, which eventually switched to showing short films amongst live entertainment. During the First World War, the Empire responded by including newsreels from the battleground. The Empire closed for the first time in 1922 and, due in part to competition from cinemas, reopened and closed several times after. In addition to variety and repertory, the Empire presented revue, opera, Carroll Levis and His Discoveries, and even the occasional ice show or circus. Perhaps television finally wrote the obituary on the much loved theatre.

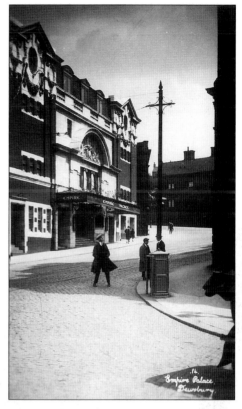

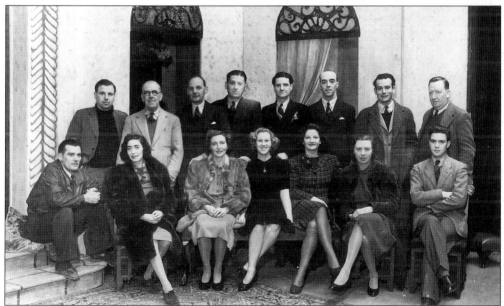

Harry Hanson's Court Players in repertory at the Empire, October 1943. They presented *East Lynne*, a drama adapted from Mrs Henry Wood's famous novel, in the first week of October (the twenty-fourth week of their season there). Subsequent productions during October included three comedies and another drama.

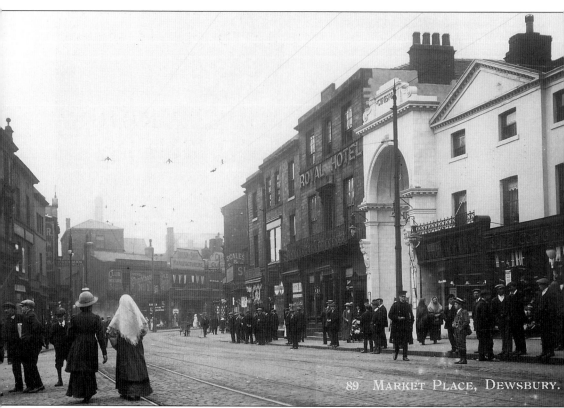

89 MARKET PLACE, DEWSBURY.

Picture House, Market Place, c. 1910. The archway, next to the Royal Hotel, led to the cinema, which was subsequently called the Regal, Essoldo, Classic, Cannon and Apollo. In its Regal days, it had a fine organ and some blue velvet double seats which occasionally had to accommodate three. In 1993, the Apollo became the last cinema in Dewsbury to close. The town's other picture houses were the Playhouse, Pioneer, Tudor and Majestic. The Playhouse, in Crackenedge Lane, did not open until 1931 and ultimately became the Mecca Leisure Centre, with bingo. The Pioneer Cinema, situated in the co-op building, and managed by the Co-operative Society, was established during 1922 in what was previously the theatre. The front entry, which led to the better seats, had a commissionaire. The rear entrance, along a dark passageway from Wellington Road, led to the cheaper seats. The Co-op building provided a complete half-day out, with a rummage around its various trading departments, a meal in the restaurant and a few pleasurable hours in its picture house. It now houses the Pot Black Snooker Club. The cinemas eventually started opening on Sundays, but not before the churches, and particularly the Nonconformists, had objected. When a referendum was held in the town during September 1951, voting was 9,809 for opening and 4,622 against. It wasn't long before they opened.

Picture House, Market Place. This card was issued to promote 'a new stage in the development of the cinema.' Crowds flocked to see the romance, which was woven around the Great Fire of London.

LADY DIANA MANNERS

will be presented

in

THE GLORIOUS ADVENTURE

The First Super-Film to be produced in Natural Colours

at the

PICTURE HOUSE
MARKET PLACE, DEWSBURY

For One Week Commencing

MONDAY, NOV. 27, 1922

at 6 & 8 p.m.

MATINEES:
MONDAY & WEDNESDAY
2.30

Theatre Royal, Bradford Street. It was erected in 1865. The back of a publicity card issued early this century is shown. The Theatre Royal had become the Tudor Cinema by the 1930s. Those who queued for the Tudor had the added attraction of watching the ever-changing colours of Dewsbury Beck, which varied according to the effluent dumped into it. The building was demolished as part of the Ring Road development.

PICTORIAL POST CARD

THE ADDRESS TO BE WRITTEN ON THIS SIDE

This space, as well as the back, may be used for communications to any place in the United Kingdom
(See Postal Regulations)

THE ADDRESS ONLY TO BE
WRITTEN HERE

Affix

Halfpenny

Stamp

DAVID ALLEN & SONS, LTD., LONDON, HARROW, BELFAST. &C.

Theatre . Royal,

DEWSBURY.

FOR SIX NIGHTS ONLY,

Commencing

MONDAY, March 21st,

Mr. C. St. John Denton's

COMPANY in

"Kitty Grey."

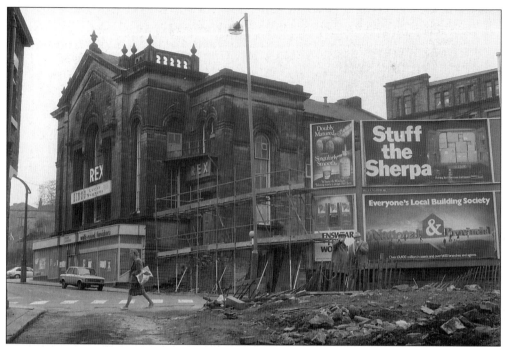

Rex Bingo Hall, immediately prior to demolition in 1985. Situated near the lower end of Wellington Road, it started life as Trinity Congregational Chapel, became the Majestic Cinema and later the Rex Bingo Hall. Underneath, the Sunday School became the Galleon Dance Hall and eventually a furniture shop.

Trinity Congregational Chapel, *c.* 1905. After closure as a place of worship, the members dispersed to Ebenezer and Springfield Congregational Chapels, the latter on Halifax Road.

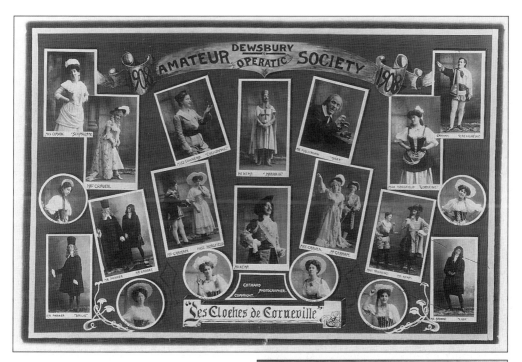

Dewsbury Amateur Operatic Society, 1908.
Their first annual musical was *Dorothy*,
performed in 1906, followed by *Merrie
England* in 1907. The 1908 production was
Les Cloches de Corneville, whose principals
are depicted above. They were supported
by a strong chorus and dance troupe.
Subsequent performances included *Haddon
Hall*, *Veronique* and *A Country Girl*. Some
of the productions were staged in the Town
Hall; others in the Empire Palace.

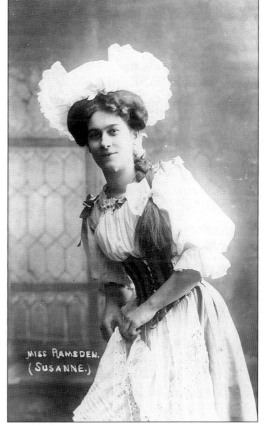

Miss B. Ramsden, playing Susanne in
the 1908 production of *Les Cloches de
Corneville*.

Boat Sam's, Ravens Wharf, River Calder, in the late 1920s. At that time, it only cost a few coppers to hire a boat and impress your girlfriend. The boat-hiring business is thought to have been started by Sam Squires around the turn of the century. After passing to various other proprietors, including A.C. Handley and Frank Hirst, it ceased in the late 1930s.

River Calder, c. 1905. Boat Sam's is faintly visible beyond the aqueduct and railway bridge. Today, a few overgrown steps on the bank are the sole remains of the enterprise. In spite of nearby industry, this was an area for relaxation.

Six

Transport

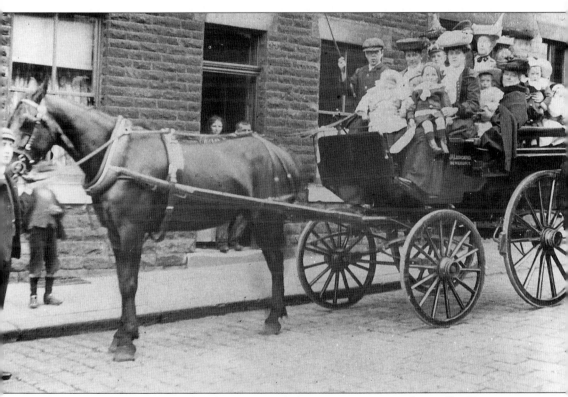

Wagonette of John Albert Ledgard, carter and furniture remover, Thornville Terrace, Huddersfield Road. Horse-drawn wagonettes, usually with facing side-seats and transverse front seats, were popular for day outings until after the First World War.

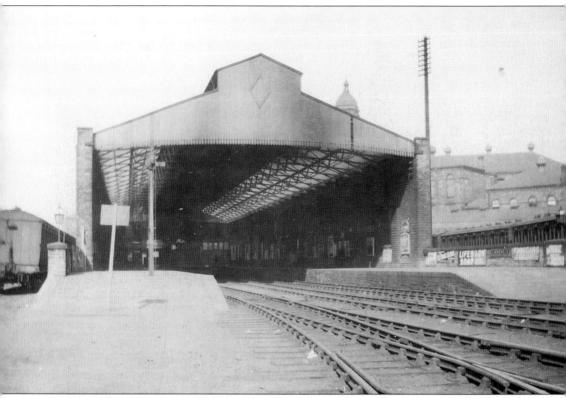

Market Place Station, *c.* 1925. Dewsbury's importance as a textile centre was reflected in its ability to support three railway stations, each with extensive goods and warehousing facilities. The stations were named Wellington Road, Market Place and Central. They opened in 1848, 1867 and 1874 respectively. Wellington Road Station is still in use, but Market Place closed in 1930 and Central in 1964. Market Place Station was the terminus of a short branch constructed by the Lancashire & Yorkshire Railway from near Thornhill on its trans-Pennine line. The station is seen here from the south. The two platforms are covered by an overall iron and glass roof, supported from stone side walls. The opposite end of the station, near the Town Hall, housed the booking hall, a small concourse and, on the first floor, the stationmaster's living quarters.

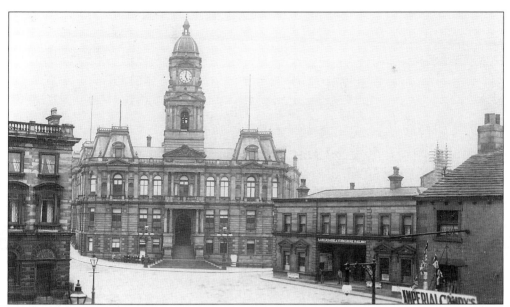

Market Place Station and Town Hall, 1903. Pedimented lower windows and decorative quoins are the main embellishments on an otherwise plain station façade.

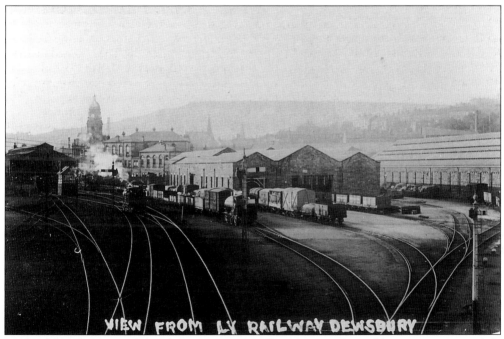

Market Place Station and Goods Depot, c. 1906. The station and signal box are at extreme left. To the right are various warehouses. The single-span shed at the far right, specifically constructed as a mungo and shoddy warehouse, was the last of the batch to be built, in 1883. The goods yard saw limited use until the 1950s.

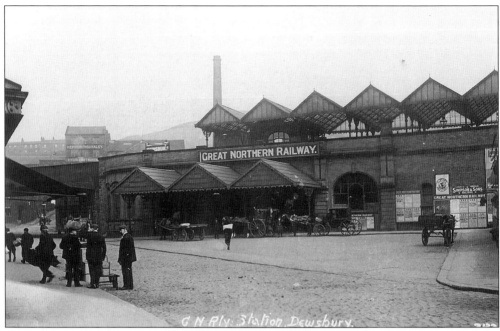

Central Station, c. 1907. Part of the Great Northern Railway network, the station provided a link with Bradford, Leeds and Wakefield. From the road, entry was gained under the ridge-and-furrow canopy and up a flight of steps.

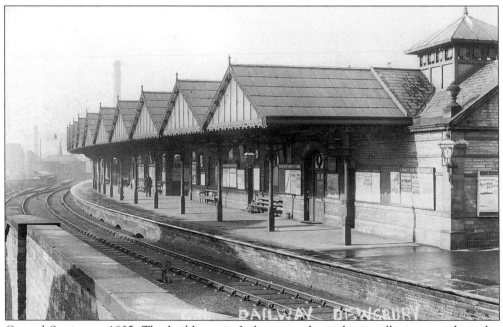

Central Station, c. 1905. The buildings, in Italianate style, with a small turret on the right, stretch along the centre of a long island platform, with ridge-and-furrow canopies at each side. This permanent station was opened in 1880 to replace a temporary one opened in 1874.

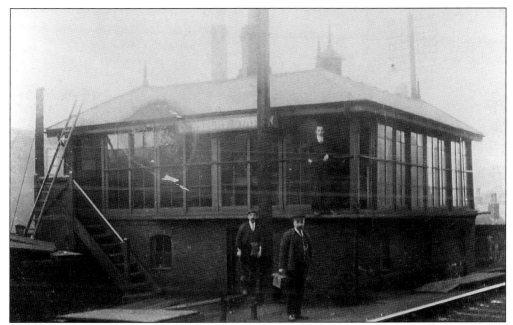

Signal box, Central Station, *c.* 1907. This was at the northwest end of the station (visible in previous picture). At the opposite end, the tracks plunged into a tunnel beneath Leeds Road and emerged on an embankment beyond Wakefield Road.

Central Station, 1985. Closed since 1964, most of the station was finally obliterated to make way for the Ring Road, part of which runs along the old track bed. This photograph affords a last look at the steps from the concourse to the platform.

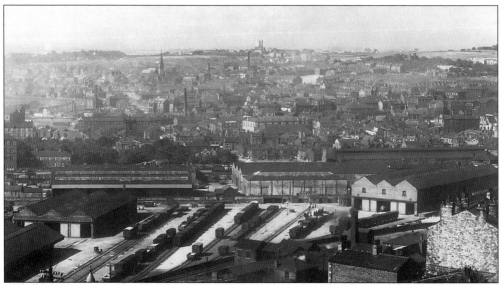

Dewsbury from the east, in the 1920s. The foreground is dominated by the freight depot of the GNR, with the line to Earlsheaton, having left the tunnel, running past various buildings, right. Further back, beyond Railway Street, is the L&YR conglomeration. Much of the former railway property is now covered with large retail outlets and car parks.

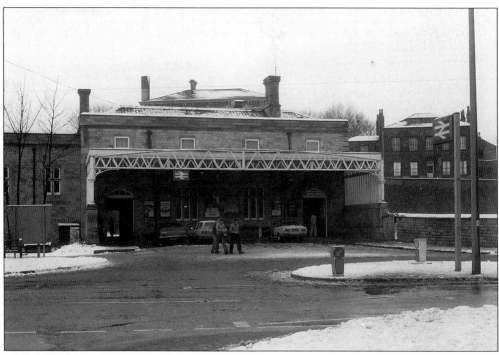

Wellington Road Station, February 1980. Although altered and reduced in size, this London & North Western Railway structure still retains many of its original Jacobean style features. Large goods sheds once stood on the adjoining car parks.

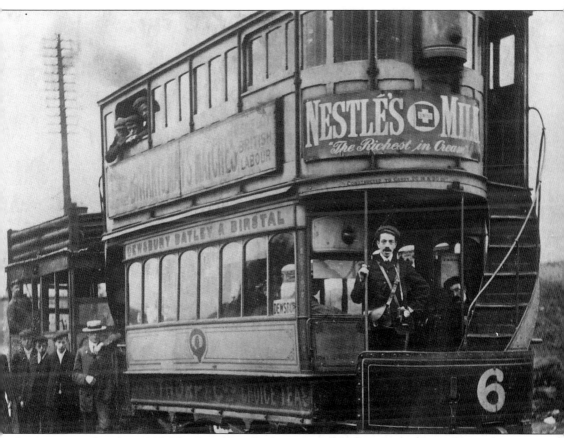

Steam tram and trailer, 1905. The Dewsbury, Batley & Birstal (*sic*) Tramway Co. Ltd started to run horse-drawn trams from Northgate, Dewsbury, to Batley in 1874. The route was extended in stages to Birstall. In 1879-81, the horse trams were replaced by steam-propelled trams, which were taken through to Gomersal. DB&B trailer No 6 is shown in its final form, when it seated twenty passengers in the lower saloon and thirty in the upper section. Board of Trade bylaws decreed that the steam engine must be enclosed and free from clatter and chimney blast. The condensers are visible on top of the engine. The British Electric Traction Co. Ltd began buying shares in the DB&B, with a view to converting to electric traction. It entered into agreements with several local authorities and, in 1901, registered a new company, the Yorkshire (Woollen District) Electric Tramways Ltd, to electrify, expand and operate the system. Construction was authorised through the Spen Valley Light Railway Order of 1901. Electric operation was phased in from 1903. Apart from Batley, other places reached included Thornhill, Ravensthorpe, Cleckheaton, Heckmondwike and Liversedge. The Dewsbury, Ossett and Soothill Nether Tramways, which was part of the National Electric Construction Co, opened a line from Dewsbury to Ossett in 1908. When Soothill Nether became part of Dewsbury in 1909, the title was changed to Dewsbury & Ossett Tramways.

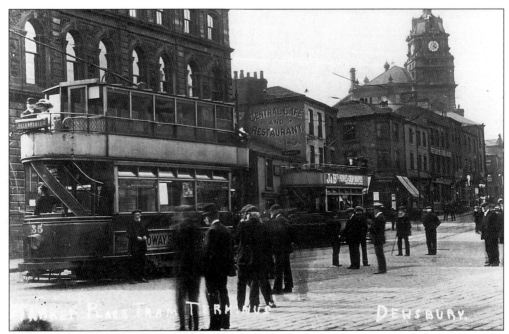

Tram terminus, Market Place, *c.* 1910. Both these tramcars are part of the first batch of double-deckers (Nos 7-48) purchased by the YWD. They were delivered from Brush of Loughborough in 1902/3 and formed the bulk of the fleet. Upper-deck covers, similar to the one shown, had been fitted to about half the batch by 1908.

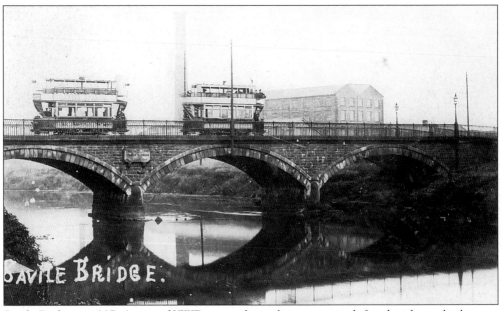

Savile Bridge, *c.* 1907. A pair of YWD trams, formerly open-topped, fitted with similar but not identical top covers, head towards Wilton Street, left.

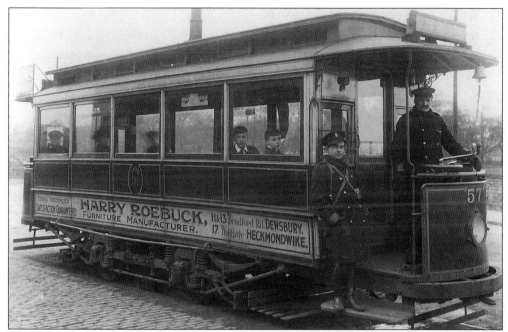

YWD tramcar No 57. Six single-deck tramcars, Nos 1-6, were bought from Brush in 1902 for the Ravensthorpe route with its two low bridges. Two similar cars, Nos 57-58, were delivered from Brush in 1903.

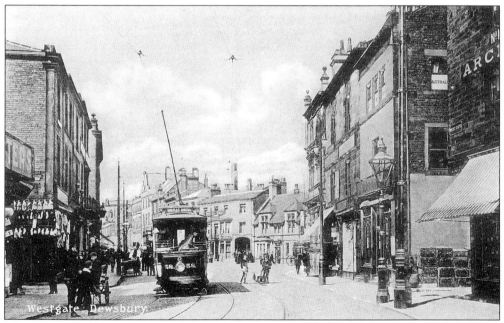

Westgate, Dewsbury, *c.* 1906. Single-deck car No 58 arrives at Market Place, its destination blind already changed for the return journey to Shepley Bridge, Ravensthorpe.

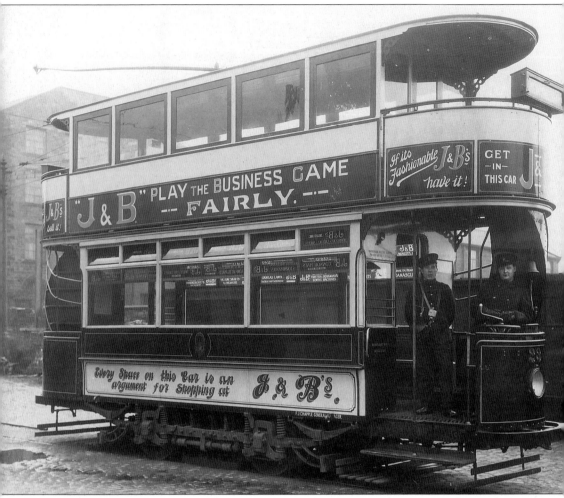

YWD tramcar No 23. Most of the cars in the 7-48 batch received an improved type of top cover from 1908 onwards. These covers were made by William Rouse & Sons, carriage builders, Heckmondwike. They had five opening windows each side, the central three being larger than the others. In postwar years, all cars in the 7-48 batch received solid curved panels around each balcony in place of part solid and part rail surrounds. Tramcar No 23 therefore appears here in its final form, *c.* 1925, and with the new maroon and primrose livery to replace the crimson and cream. The handbell near the driver's head had replaced the foot gong of earlier days. With one hand on the controller, the other on the brake handle, how did the driver manage to ring the bell?

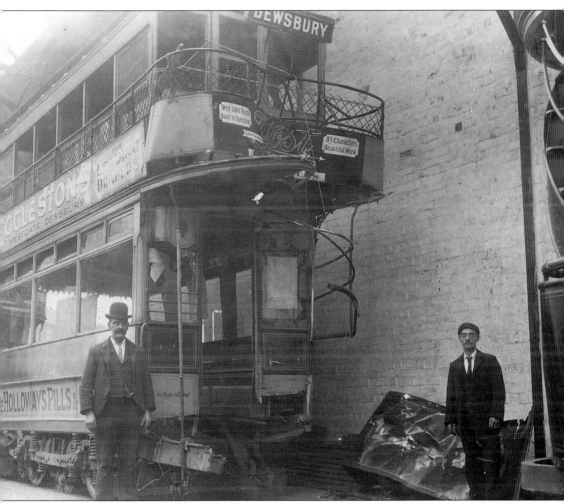

Tram accident, 20 May 1904. Shortly before 3 o'clock, YWD tramcar No 7 was on a return trip from Cleckheaton. Reaching the steep gradient opposite the Infirmary in Halifax Road, the driver applied his brakes, which failed to act. The car started to descend the hill at a terrific speed. Near the Bath Hotel, it knocked over a wagon of mineral waters. At Willans Road, the driver was thrown off. Passengers attempting to jump off were restrained by the conductor who stayed at his post. In Northgate, the runaway car crashed into the rear of a tram from Birkenshaw. The impact pitched the conductor of this tramcar through Miss Fullerton's shop window. A coal cart was upset on to the pavement, causing damage to the Bon Marche shop. A wagon belonging to Garthwaite Bros., manufacturing chemists of Dewsbury Moor, was overturned, the bottles breaking and discharging vitriol into the road. The runaway car jumped off its own tracks and landed on the other set. Slowing down, it came to rest outside the London, City & Midland Bank in the Market Place, after crashing into a Ravensthorpe tram. Nobody was killed but several people were injured. A lady and gentleman on the wayward car, who were on their way to the railway station, en route for Blackpool, were bruised but refused to forego their Whitsuntide excursion. The damaged tramcars were taken to the depot at Savile Town, where No 7 is pictured above. At the Board of Trade enquiry, blame was attached to the driver who panicked, rather than the brakes.

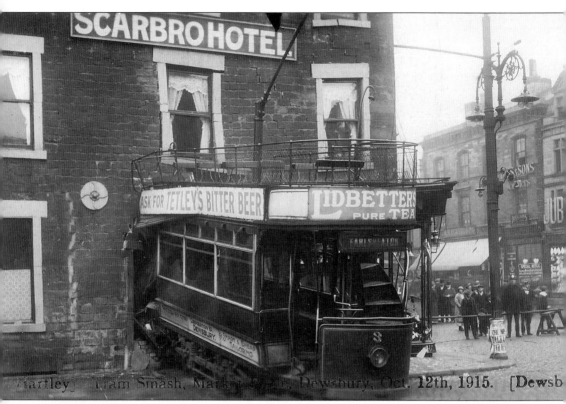

[Hartley] Tram Smash, Market Place, Dewsbury, Oct. 12th, 1915. [Dewsb

Tram accident, 12 October 1915. The Dewsbury & Ossett Tramways operated a line from Dewsbury to Ossett, with a branch to Earlsheaton. The Dewsbury terminus was at the side of the Lancashire & Yorkshire Bank (later Barclays) near the Town Hall, and at the bottom of a 1 in 10 gradient. The D&O tramcar No 3, the 4.15 p.m. from Earlsheaton, ran out of control after entering the Wakefield Road cutting and, gaining speed, collided with a pony and cart near Rishworth Street. The counductress jumped off beside the Town Hall. The car crashed into a horse and cart, overran the terminus and embedded itself in Hilton's shoe shop, as shown. A fire broke out but was soon extinguished by the brigade. With only three passengers on the offending car, injuries were few. At 5.30 p.m., soon after the photo was taken, the upper storeys of the building, which were used by the adjoining Scarborough Hotel, collapsed on to the tram.

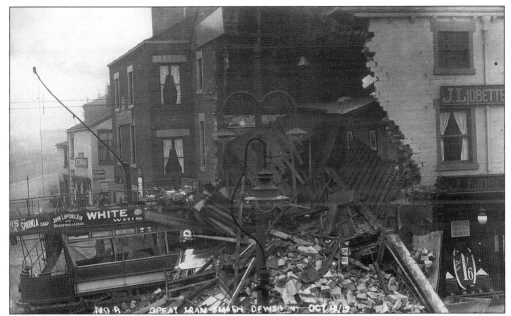

Tram accident, 12 October 1915. The main part of the Scarborough Hotel is visible beyond the tramcar. At the Board of Trade enquiry, the accident was attributed to greasy rails, caused by a shower of rain and an accumulation of coal dust from nearby Ridings Colliery.

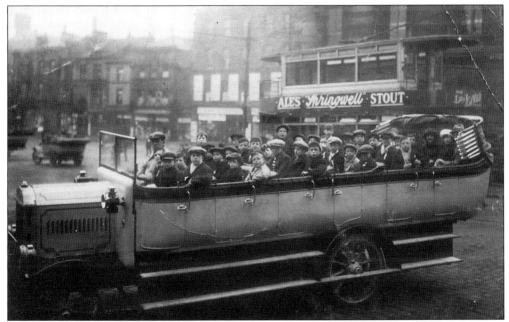

Charabanc and tramcar, early 1920s. The tram is at the D&O terminus. Destination and identities of the charabanc party, parked in front of the Town Hall, are unknown.

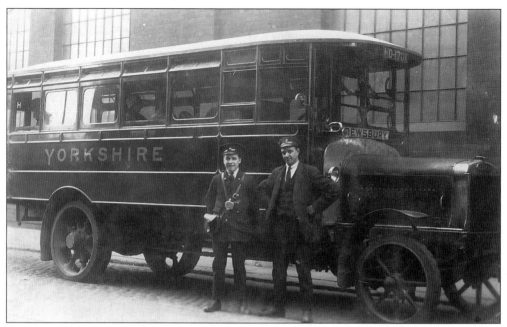

Yorkshire Woollen District bus No 9 (HD 1701). The vehicle, new in 1922, has a Leyland N type chassis and twenty-eight seat body. Working the Dewsbury-Leeds route, it is parked in Swinegate, Leeds. The company commenced bus operation in 1913.

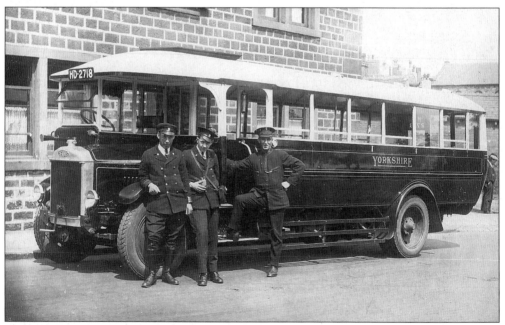

YWD bus No 37 (HD 2718). New in 1926, the Dennis E type chassis has a Brush thirty-two seat body. The uniformed trio includes Chief Inspector Wood (with his foot on the steps).

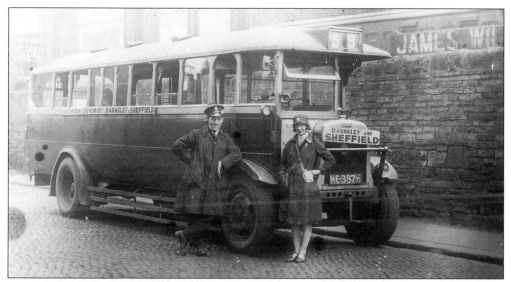

Yorkshire Traction bus No 178 (HE 3875). The vehicle, new in 1928, has a thirty seat Brush body on a Leyland PLSC3 chassis. It stands on Long Causeway, with the L&Y Railway Station behind. Yorkshire Woollen and Barnsley-based Yorkshire Traction operated a joint service between Dewsbury and Sheffield.

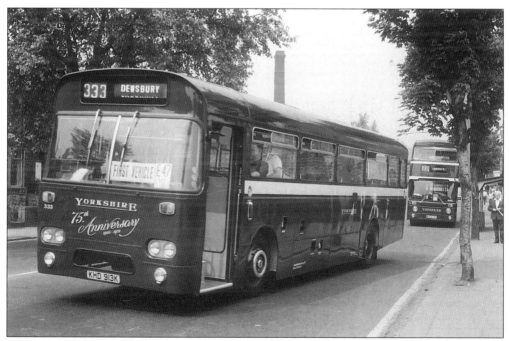

YWD bus No 333 (KHD 913K). It was one of two vehicles (the other is behind) repainted in pre-war maroon livery to celebrate the company's seventy-fifth anniversary. The buses are shown on ferrying duty for the open day at Savile Town Depot on Sunday 4 June 1978.

Bus Station, 1978. It was demolished two years later to make way for the Princess of Wales Precinct. The replacement bus station, which adjoins South Street, was opened in 1979, but underwent a rebuild in 1994.

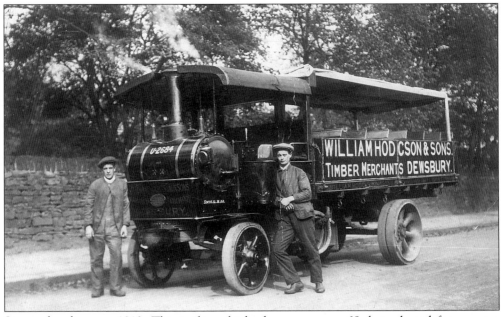

Steam charabanc, c. 1913. This is the vehicle shown on page 68, but adapted for use as a charabanc. Temporary conversions such as this were not unusual.

Seven
Personalities

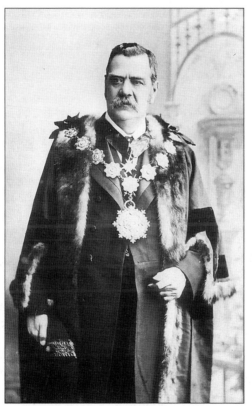

Major Chaley Fox JP, Mayor of Dewsbury, 1904/5. He was the son of Ephraim Fox, mungo and shoddy manufacturer at Calder Bank Mills, Huddersfield Road. With his brother Joseph, he played a prominent part in the formation of the Dewsbury Conservative Association.

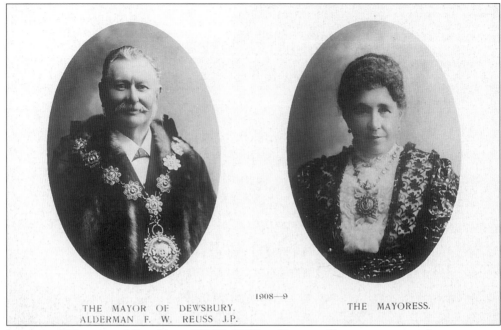

Mayor and Mayoress of Dewsbury, 1908/9. William Reuss, a German, came to the town as an agent for a foreign company which was interested in the rag trade, and soon became involved in local affairs. He resided at Friedberg House, Park Road.

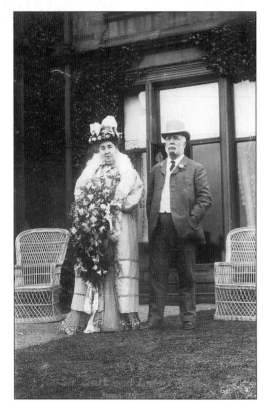

Sir Mark and Lady Oldroyd, 26 June 1909. He was born at Spinkwell in 1843 and married Maria Mewburn of Banbury in 1871. She died in 1919, but Sir Mark remarried in 1920. A Liberal and Nonconformist, he was intended for the Congregational ministry, but joined his father's business instead. Mark Oldroyd became Mayor of Dewsbury in 1887 and was the town's MP from 1888 to 1902. He was knighted in 1909 and died in 1927.

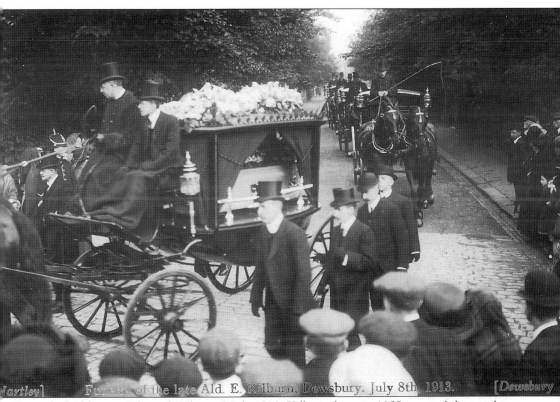

Funeral of the late Ald. E. Kilburn, Dewsbury. July 8th, 1913.

Funeral of Alderman Edmund Kilburn, 8 July 1913. Kilburn, born in 1855, entered the employ of his uncle, Benjamin Eastwood, rag auctioneer, Bradford Road, in 1870, eventually becoming a senior partner. Associated with All Saints' Parish Church and later St John's, Dewsbury Moor, he became a Sunday School teacher and lay reader. A Conservative, he sat on several committees, became mayor six times, and was an advocate for enlargement of the town, plus its elevation to County Borough status. After two years of failing health, Kilburn died on 4 July 1913, aged 57. The funeral was attended by the Mayor and Corporation, police, freemasons, magistrates and many private mourners. The cortege left Kilburn's residence at Eastburn House, Park Road at noon on 8 July 1913 for a service at St John's Church, before proceeding through Crow Nest Park to the nearby cemetery. All the proceedings were accompanied by the singing of hymns and choral pieces. In the town, flags were flown at half mast and shop blinds were drawn.

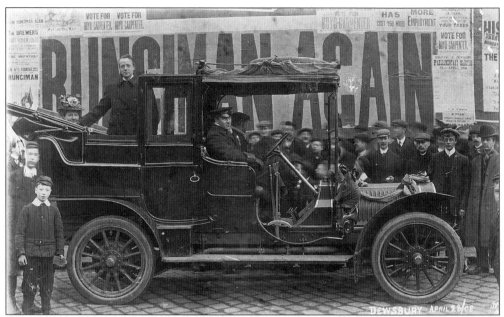

Walter Runciman, 23 April 1908. Born in South Shields in 1870, he obtained an MA degree in 1895. He was elected MP for Dewsbury in January 1902 to succeed Mark Oldroyd. He is depicted at his second re-election. In the Cabinet, he became President of the Board of Education in 1908 and President of the Board of Trade in 1914. With the collapse of the Liberal Party in 1918, Runciman lost his Dewsbury seat. He died in 1949.

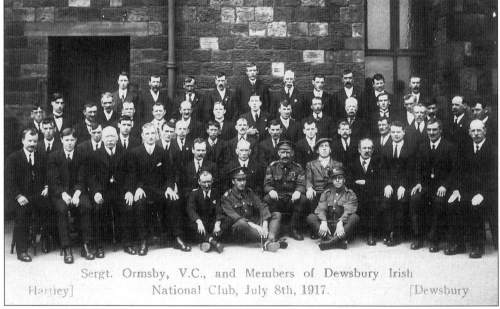

Sgt Ormsby VC, 8 July 1917. In the First World War, Dewsbury had two Victoria Cross winners – Sgt William Ormsby and Pte Horace Waller. The former was sited for bravery in leading the capture of an important enemy position. A Roman Catholic, Ormsby is shown, centre, with members of Dewsbury Irish National Club.

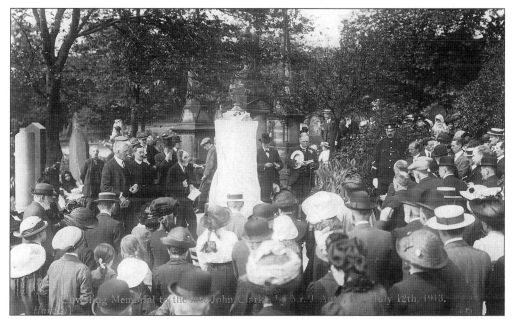

Unveiling of memorial to John Clarke by Joseph Auty JP of Batley, in Dewsbury Cemetery, 12 July 1913. Clarke originated in the west of Ireland. He became a popular, if eccentric, indoor and outdoor orator in and around the town. £53 was raised for the memorial, which cost £42.

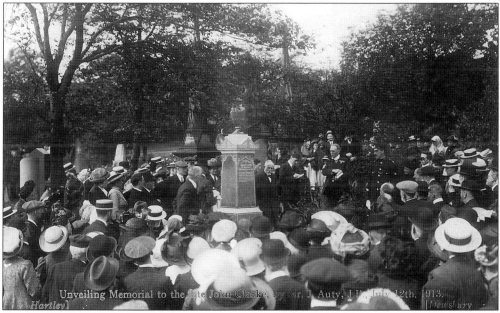

Unveiling of the memorial to John Clarke. The inscription on the granite stone reads, 'In memory of John Clarke of Dewsbury, who died April 26th 1913, a zealous advocate of temperance, of education and of free speech, and a staunch supporter of every cause that makes for righteousness and the well-being of the people.'

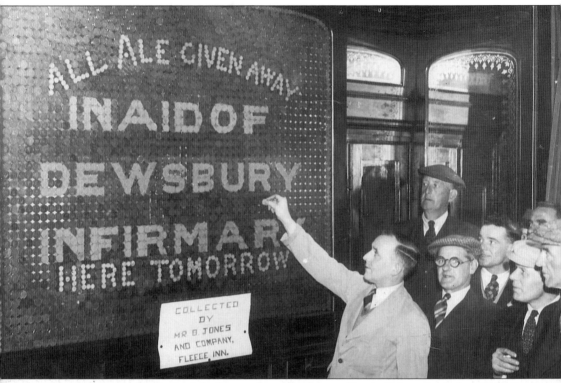

Bernard Jones, landlord of the Fleece Inn, Northgate. He, in light-coloured coat, is placing coins on a mirror at the pub. During the 1940s and '50s, Bernard, an ex miner, also owned several fish-and-chip shops, and the men's haircutting and shaving salon in the Market Place, next to Boots. His manager there was Jack Gautry. Five or six barbers were employed, plus Ken Lister as lather boy. Ken worked part-time at the salon before leaving school, when he became a full-time employee. Each hairdresser was allowed half-an-hour for lunch. Apprentice Ken was expected to make several trips across the road to collect their meals from Bailey's restaurant. Shaving with a cutthroat razor was an important part of barbering. The establishment had an electrically-powered instrument for removing warts and treating facial skin complaints. Ken Lister subsequently set up his own hairdressing business in Ossett. Bernard Jones owned some greyhounds, his best-known being a large brindle called Duke Street Dan. Another greyhound was used for breeding, the pups being given names with the same initials as the owner, e.g. Beautiful Journey and Best Judge. Bernard organised the collecting event depicted above for Dewsbury Infirmary. Coins were stuck on mirrors at the Fleece Inn. The value of coins on the above mirror reached £18-3-4; on a smaller mirror £3-5-8. A gussing competition on the large mirror realised another £2-16-3. Postcard copies of this photo were sold at 6d each. The biggest attraction must have been the giveaway ale. But then, Bernard was something of an entrepreneur.

Eight
Events and Disasters

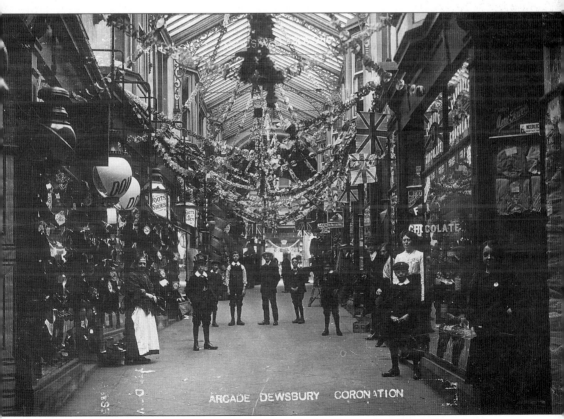

The Arcade, looking towards Corporation Street, with the Coronation decorations, 1911.

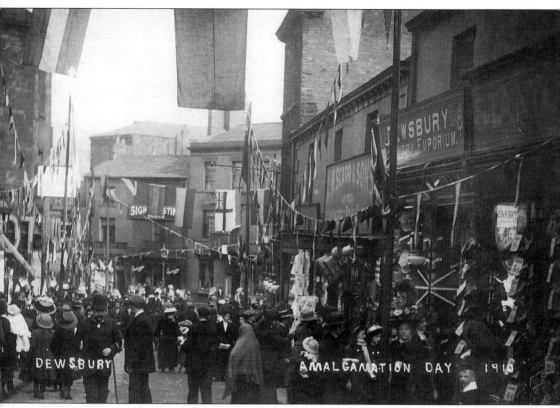

Amalgamation Day, 2 April 1910. Following prolonged local agitation for a Greater Dewsbury, the Local Government Board's order for the expansion was received in April 1909. This resulted in the almost doubling of the population of the Borough of Dewsbury from 28,000 to 53,000, with the incorporation of Ravensthorpe, Thornhill, Soothill Nether (Earlsheaton) and part of Soothill Upper. The total area was increased to 6,720 acres. The first election of councillors for the enlarged borough was held on 22 March 1910 and the first council met on 1 April. Celebrations included a decorated tramcar and decorations in all the main thoroughfares. The trimmings at the lower end of Daisy Hill are depicted. A further accolade came in 1913 when the Metropolitan Borough of Dewsbury was elevated to a County Borough.

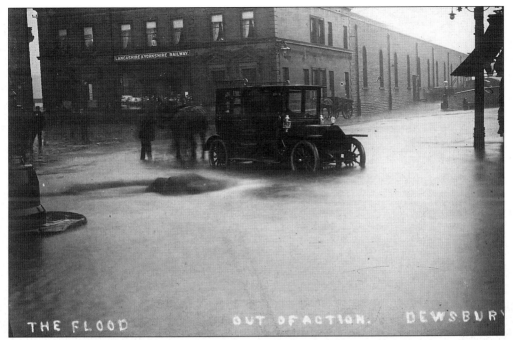

Flood, Market Place, 9 June 1910. Until the 1960s, the centre of Dewsbury was, with heavy rain, liable to flooding from Dewsbury Beck, during its flow beneath Crackenedge Lane and Long Causeway towards the Calder.

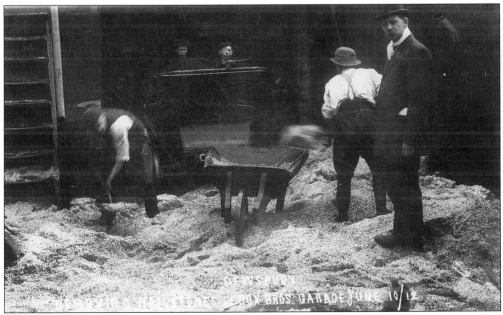

Hailstones, 10 June 1912. A severe thunderstorm ended with a downpour of hailstones which covered some parts of the town to a depth of several inches. Above, an attempt is being made to shovel them out of the garage of Box Bros., Crackenedge Lane.

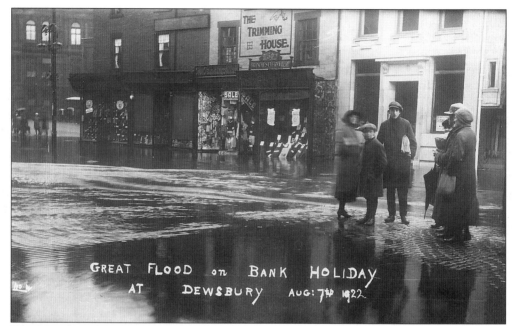

Flood, Market Place, 7 August 1922. 'What a rainy day we had on Bank Holiday Monday. The tailor's shop had a tremendous lot of cloth and suits soddened, but you can see it was as high as the window.' So runs the message on the back of this card, referring to Kellett's Trimming House. Some of the nearby cellar dwellings were flooded up to the ceiling.

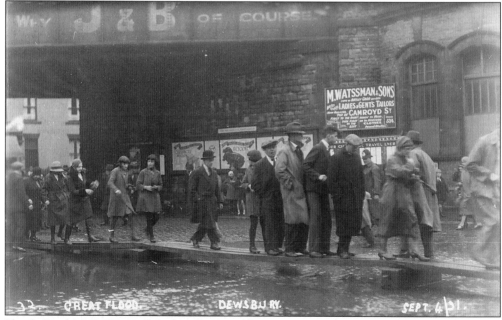

Flood, Crackenedge Lane, 4 September 1931. Young and old 'walk the plank' underneath the railway bridge.

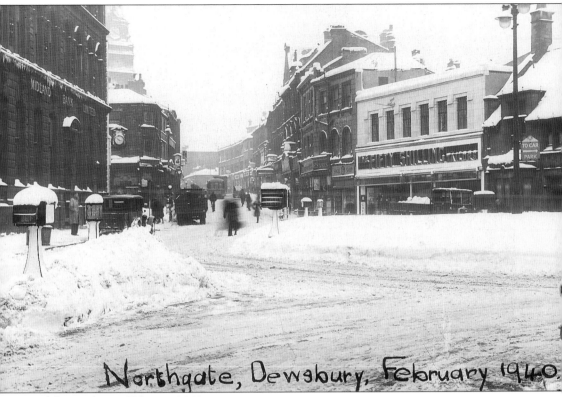

Snowfall, Northgate, February 1940.

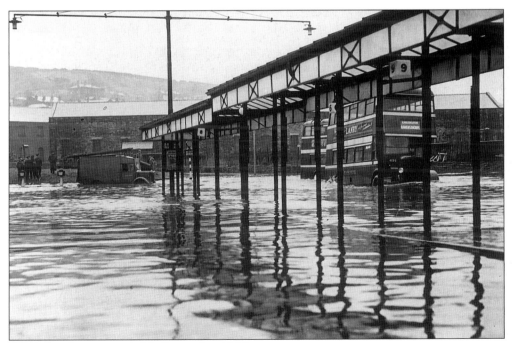

Flood, Bus Station, probably September 1946.

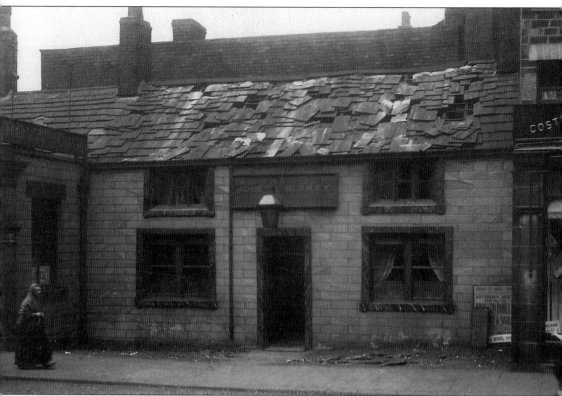

Gas explosion, Royal Oak, 11 June 1911. This pub was situated at the corner of South Street and Church Street (where McDonald's restaurant now stands). Annie, aged 22, daughter of landlord Joseph Blakey, retired to her bedroom after closing time and struck a match. This caused a terrific explosion, which was heard in the Market Place. PC Wilkinson, who was on duty there, hurried to the scene, where a crowd had gathered. Annie, suffering from burns to her face and hands, was taken to a nearby house to receive medical attention. Mr Blakey was in Bridlinton; his wife and daughter Louise, aged 14, were shocked but uninjured. The pub roof suffered badly, several windows were blown out, and the kitchen and snug were damaged. The explosion was caused by a gas leak from an old pipe.

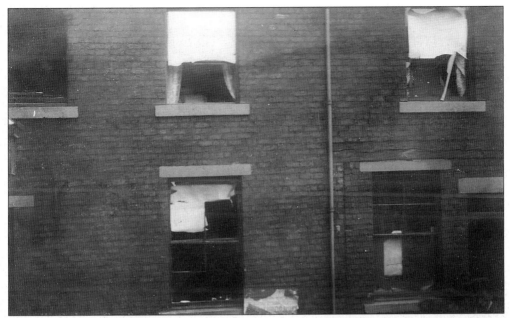

Gas explosion, Royal Oak, 11 June 1911, showing the rear of the pub.

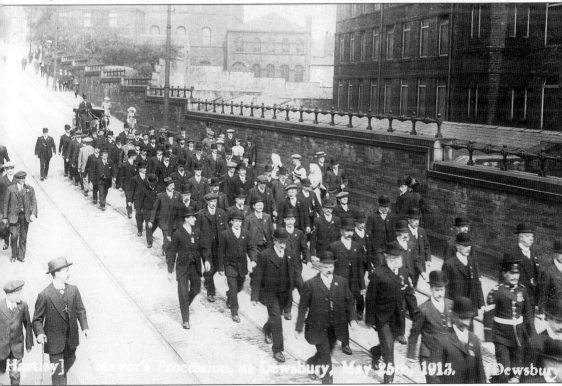

Mayor's Procession, 25 May 1913. A contingent of the parade marches down Halifax Road. On the right is part of Spinkwell Mills, whilst up the hill is Springfield Congregational Chapel. Both these buildings have been demolished. The event culminated with a service in the Parish Church.

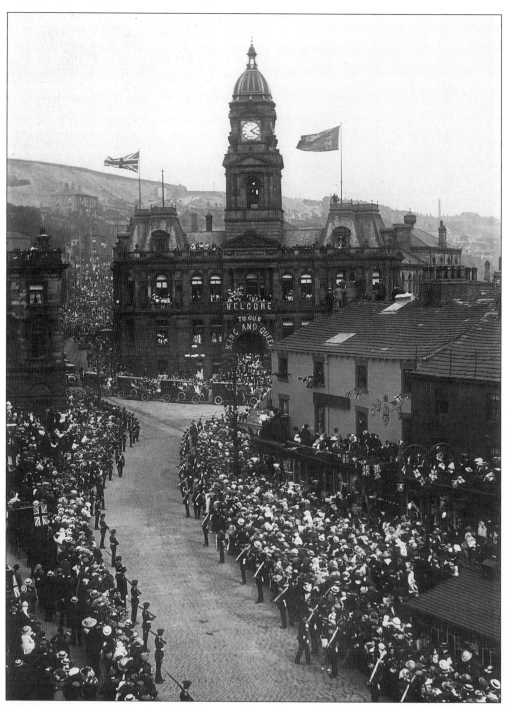

Visit of King George V and Queen Mary to Dewsbury, 10 July 1912. The motorcade arrives in front of the Town Hall, having travelled along Wakefield Road from Ossett. On the day, the royal couple toured through several industrial towns in the West Riding, including Wakefield, Ossett and Batley.

Town Hall, decorated for the King and Queen's visit, 10 July 1912.

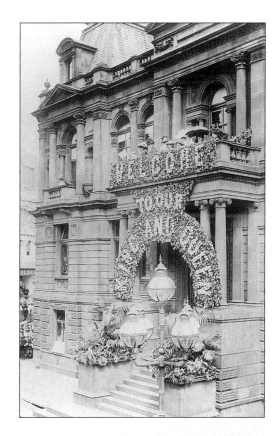

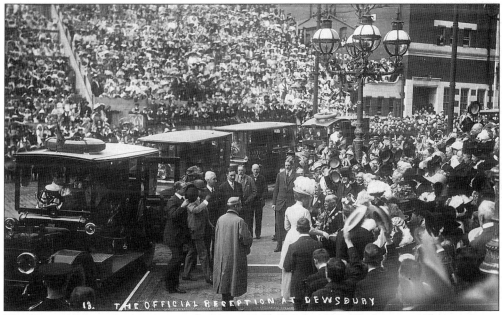

The King and Queen's reception at the Town Hall, 10 July 1912. The Mayor, Alderman James Greenwood, welcomes the Queen. The specially-constructed platform in the background accommodates some of the thousands of schoolchildren attending.

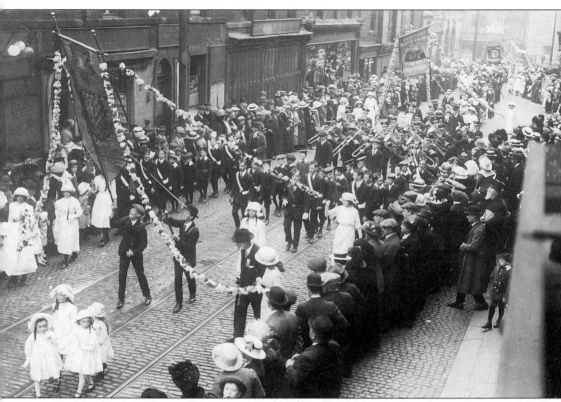

Dewsbury Parish Church Whitsuntide Procession, Northgate, *c.* 1914. Virtually every church and chapel held its own Whit Walk, usually followed by tea, buns and sports. Care was needed to prevent the parades clashing, some taking place on Monday, others on Tuesday. Halts were made to sing special hymns, accompanied by a band or harmonium. The processions included Sunday School children, teachers, parents and uniformed organisations. Children wore their new clothes. Four small girls in front of this parade look particularly bonny in their white attire. The clothes were also worn at Sunday School Anniversary services, sometimes spread over two or three Sundays.

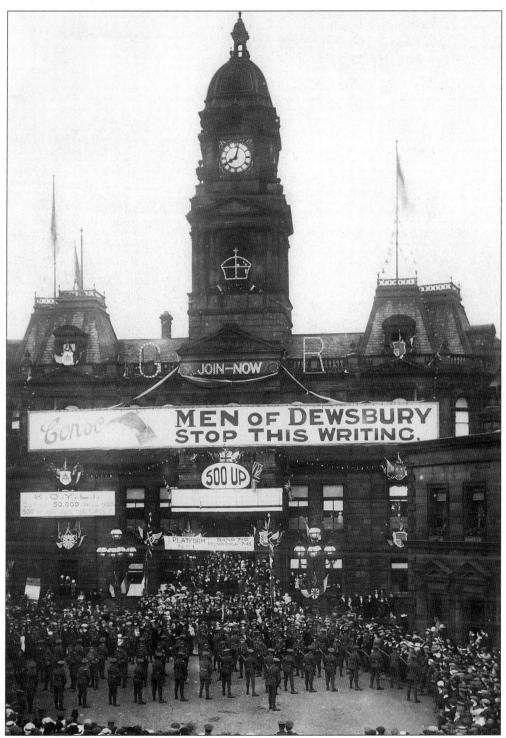

Recruiting Campaign, August 1915. In an effort to boost national service recruitment during the First World War, especially for the King's Own Yorkshire Light Infantry, the Town Hall was decorated and special events held. The aim was 500 local recruits.

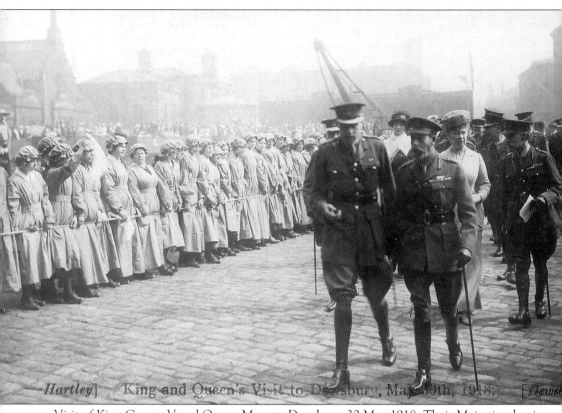

Hartley] King and Queen's Visit to Dewsbury, May 30th, 1918. [Dews]

Visit of King George V and Queen Mary to Dewsbury, 30 May 1918. Their Majesties, having arrived by train, pass through the yard of Wellington Road Station, visible in the background, on their way to the nearby Army Ordnance Depot. This was established by the government for receipt and sorting of discarded military clothing. Women workers from the depot line the yard. The King is accompanied by Major F.H. Chalkley MBE, Chief Ordnance Officer, Dewsbury. The King and Queen also visited several factories engaged on war work, including Spinkwell Mills (Mark Oldroyd & Sons Ltd, woollen manufacturers), Calder Bank Mills (E. Fox & Sons Ltd, mungo and shoddy manufacturers) and Britannia Mills (Wormalds & Walker Ltd, blanket manufacturers).

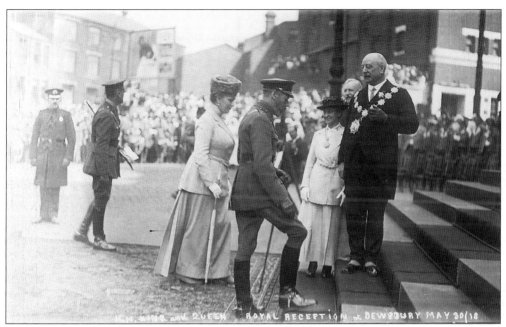

Royal visit, 30 May 1918. King George V and Queen Mary are welcomed at the Town Hall by the Mayor, Alderman Walter France, and Mayoress. Note the carpets.

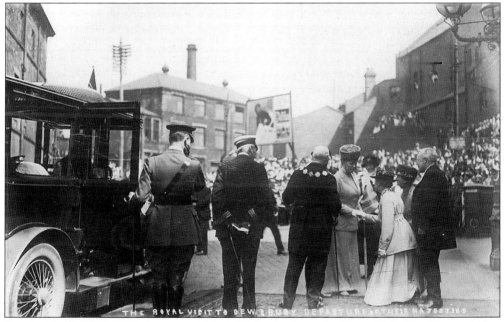

Royal visit, 30 May 1918, departure of their Majesties from the Town Hall. The Queen shakes hands with the Mayoress.

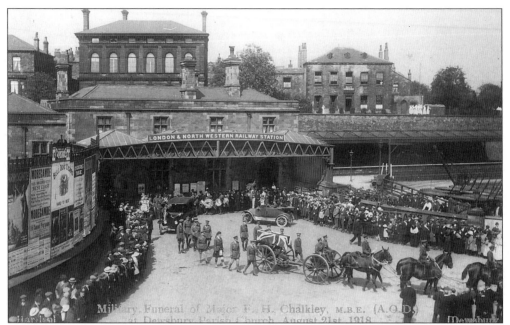

Military funeral of Major F.H. Chalkley MBE, 21 August 1918. Major Chalkley died in Llandudno on 17 August while convalescing from an illness. He was brought to Wellington Road Station and borne on a gun carriage, pulled by six bay horses, through the town to the Parish Church. Apart from showing the cortege, this photo provides an excellent view of the station.

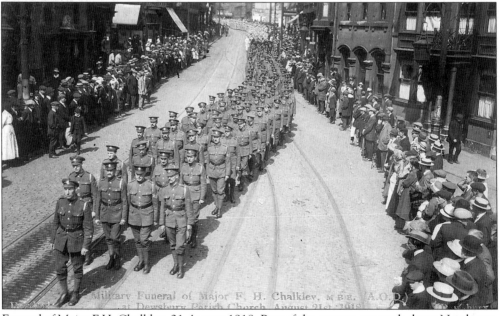

Funeral of Major F.H. Chalkley, 21 August 1918. Part of the cortege proceeds down Northgate.

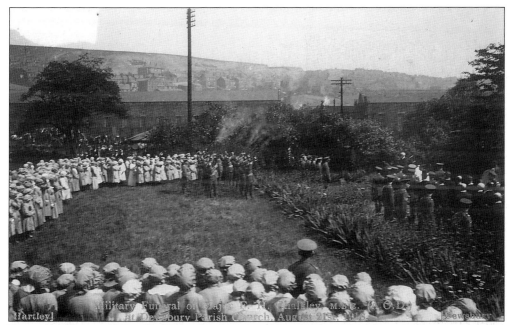

Funeral of Major F.H. Chalkley, 21 August 1918. Soldiers fire three volleys during the interment in the churchyard, while workers from the local Ordnance Depot look on.

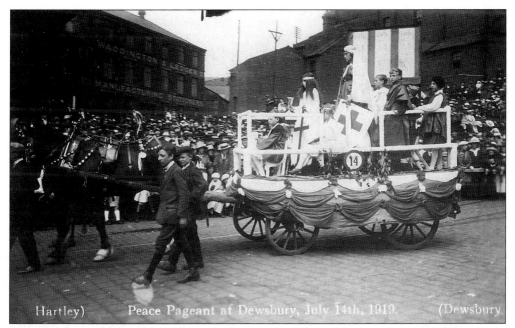

Peace Pageant, 14 July 1919. A decorated float, part of a long procession, passes the Town Hall. The Empire is on the right.

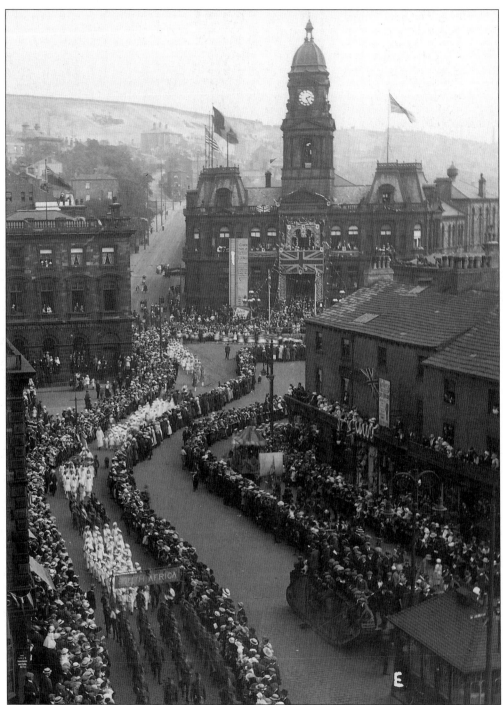

Peace Pageant, 14 July 1919. It followed Victory Loan Week, when the tank, lower right, was presented to the Dewsbury War Savings Committee to raise money for the loan. A large panel has been erected to the left of the Town Hall steps, with 'Jack' climbing a 'beanstalk' to show the amount raised. The procession moves along one side of the Market Place, past the Town Hall, and along the other side.